COMING BACK
NEW ORLEANS RESURGENT

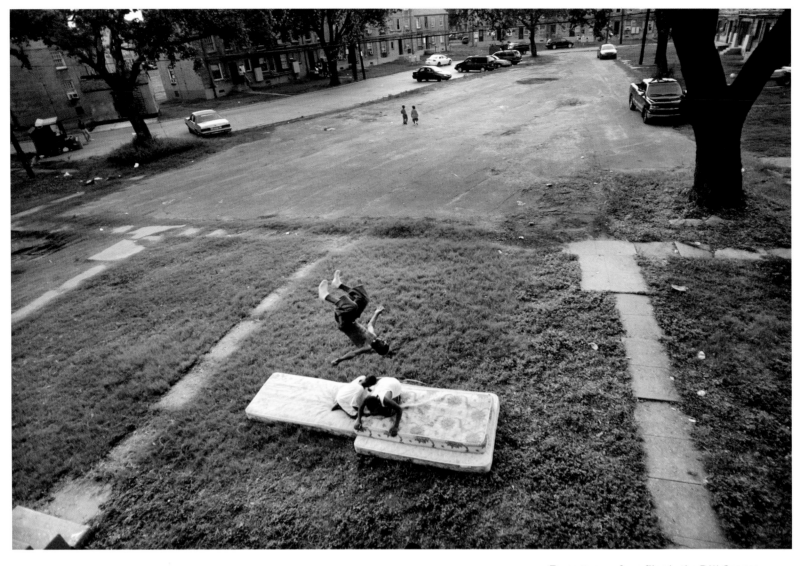

Teenagers perform flips in the B.W. Cooper
housing project, also known as the Calliope,
June 10, 2007, New Orleans.

COMING BACK
NEW ORLEANS RESURGENT

Photographs by Mario Tama

Introduction by Anderson Cooper

In association with
New Schools for New Orleans

gettyimages®

umbrage

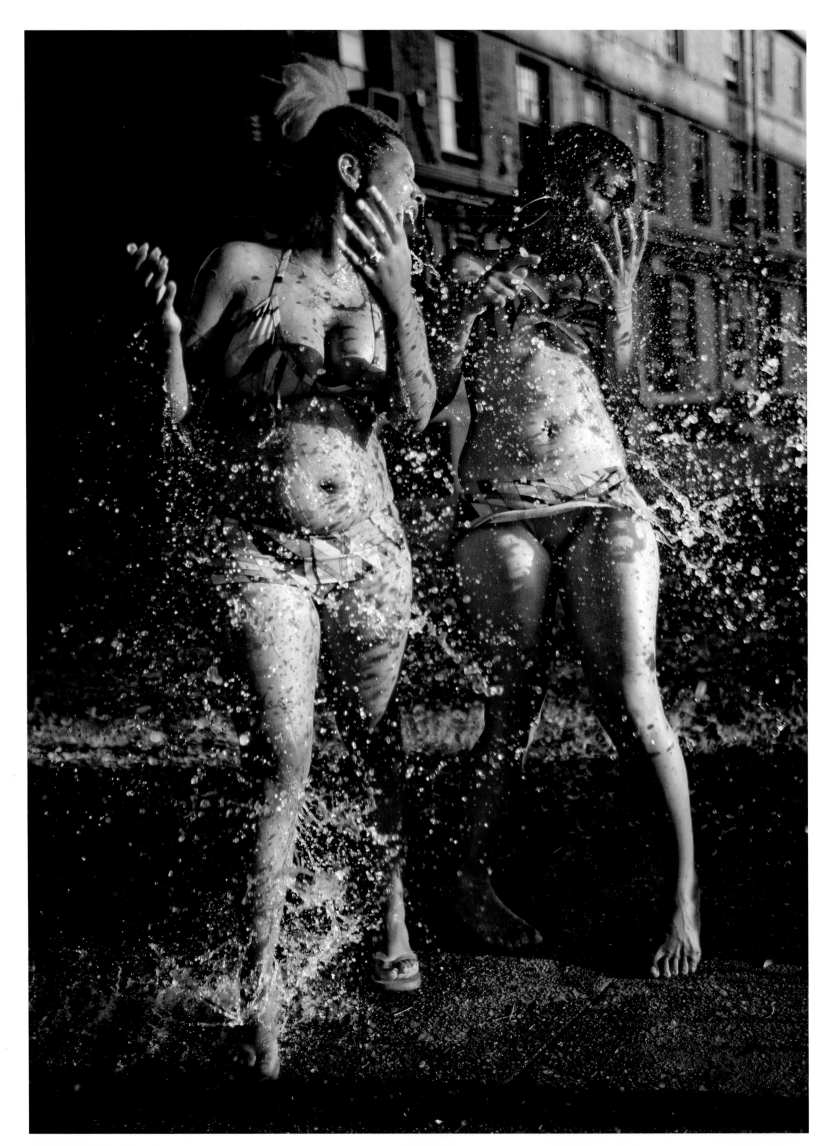

CONTENT

Residents are splashed with water during a memorial birthday party for 12-year-old Keith Franklin, who was accidentally shot and killed by a 13-year-old friend, August 25, 2007, New Orleans. The party also honored Keith's surviving twin brother Kent, who turned 13 the same day.

At the moment this book goes to press, the eyes of the world are once again on the Gulf Coast.

As the oil spill from the BP well permeates and advances across the waters, the catastrophe is a stark reminder of the fragility of the environment and the communities pictured herein. May the spirit and resilience of the people of New Orleans and the entire region overcome—yet again.

—Mario Tama

INTRODUCTION
Anderson Cooper

A couple of weeks after Katrina hit, I was driving around New Orleans with a police officer. We were passing the deserted convention center, looking at all the refuse that had been left behind when the people who had camped out there were finally evacuated.

"Mark my words, man, it's all going to be cleaned up and forgotten. These people are poor, no one's going to speak for them."

He was right, of course. Much of what happened in those dark, difficult days in New Orleans and neighboring communities along the Mississippi Gulf Coast has been forgotten. Not by the people who actually lived through it, but much of the rest of the country seems to have moved on. You can't really blame them, of course. It's been five years now. Five years. The images, the promises, the lessons, which made headlines for a few days and weeks, have faded. It is always this way after a disaster. Part of it is natural, and probably good. Life moves forward, a new city replaces the old, people adapt; there is little choice.

The "story" is over, I've been told by a lot of people, and I think they actually believe it. The truth is a lot more complicated than that. What happened in New Orleans did not stop with the storm winds, it did not disappear with the floodwaters. In fact, it never was a "story" to be packaged, and produced, and put away. It was real. Real life. Real death.

Katrina showed us many things—some horrific. Some heroic. In Katrina we saw, viewed through the distorted lens of politics, economics, and history, how some lives seemed to be judged more important than others. We saw in Katrina how hollow political rhetoric can be. But we also saw

the strength of individuals, the power of faith, and what can happen when people reach out to help one another.

Over the last five years in New Orleans, the hard work of making the world again has been left in large part to the residents of that city. They have taken on that challenge, and porch by porch, block by block, built their lives anew.

I live in New York, a city rich in history, but you have to look hard to find it. New York tears down the old, builds gleaming monuments to the new. New Orleans has never tried to erase its past. It does not rewrite its history, it simply adds to it: layer upon layer, the pain, the pleasure, all visible still. If you are willing to see it, New Orleans reveals itself to you. It is like reading the rings on a tree. The past is alive in the present. You just have to keep your eyes open as you walk its streets. It is a city of memory, but not a museum. It is alive, and dynamic, full of life and joy, and success.

Mario Tama covered Katrina, but unlike so many others, he has repeatedly returned to New Orleans. He remembers not only what happened, but has committed himself to documenting what is still happening in the once water-soaked streets. That is why his reportage is important. This book, and the exhibition it accompanies, is a celebration of a city, a people, and a spirit.

In Mario Tama's work you can hear the people of the new New Orleans speak. You see their strength, their resilience. You hear their music and get a glimpse of how they and their city returned from the brink. It is a celebration, and a prayer. A prayer for what has been lost, and that which has been found again.

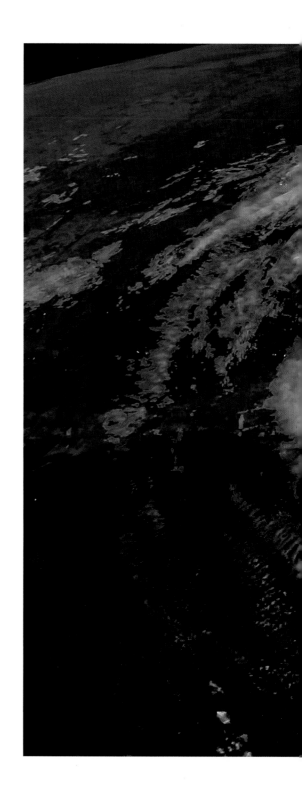

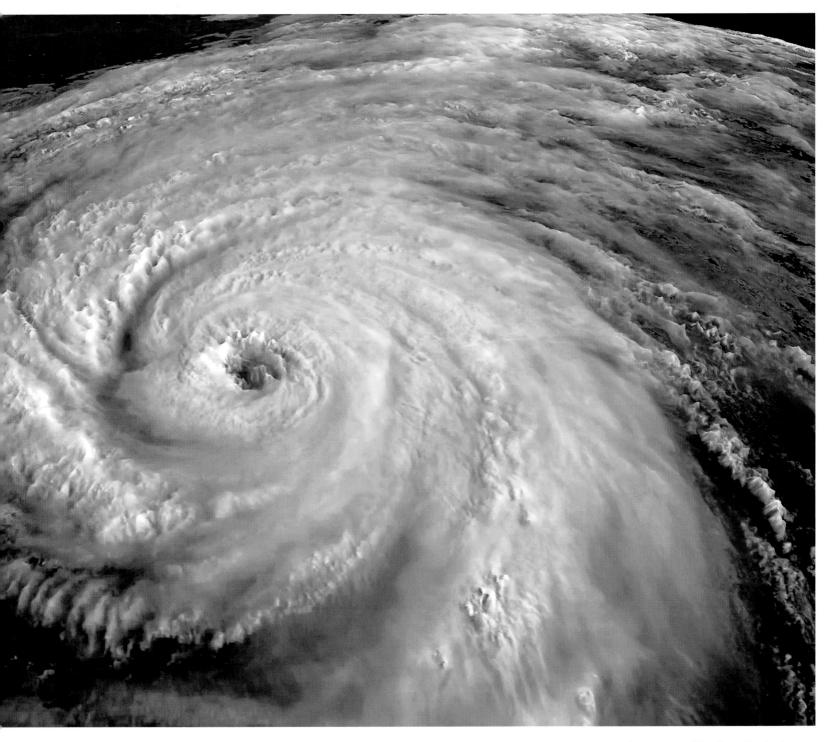

A satellite image from NOAA shows a view of the center of Hurricane Katrina's rotation at 8:45 a.m. CDT on August 29, 2005, over southeastern Louisiana.

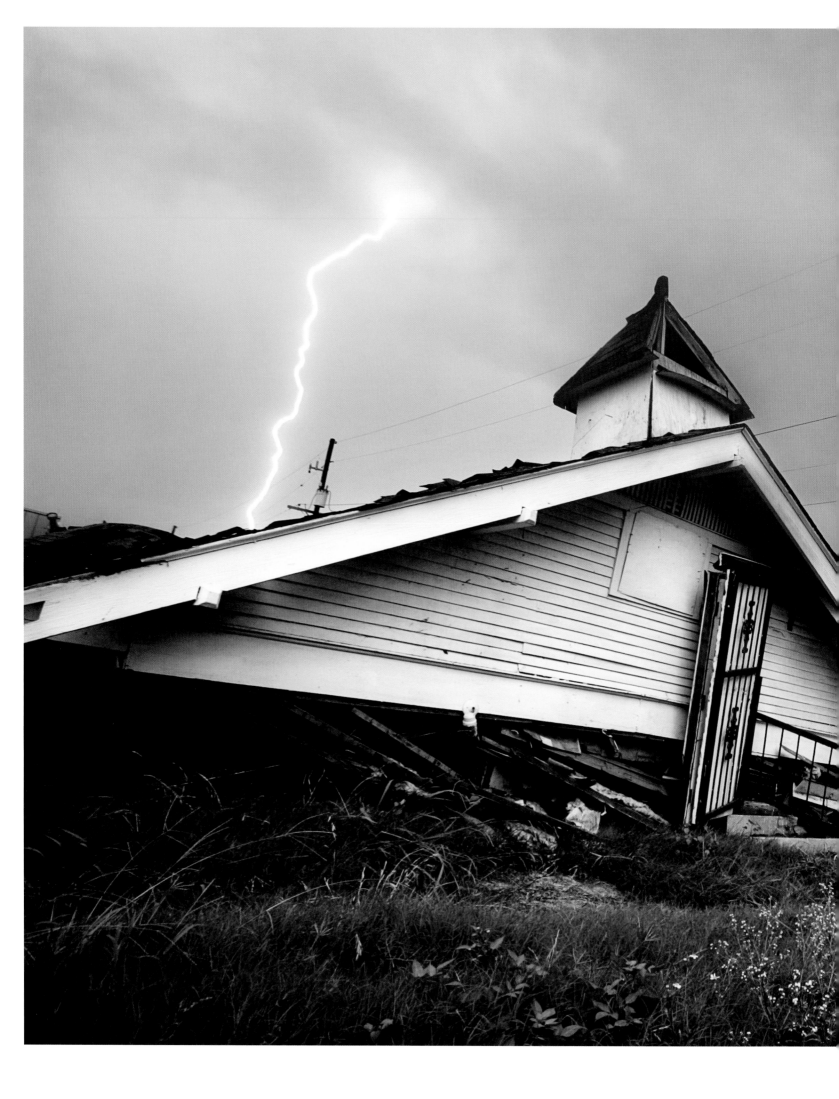

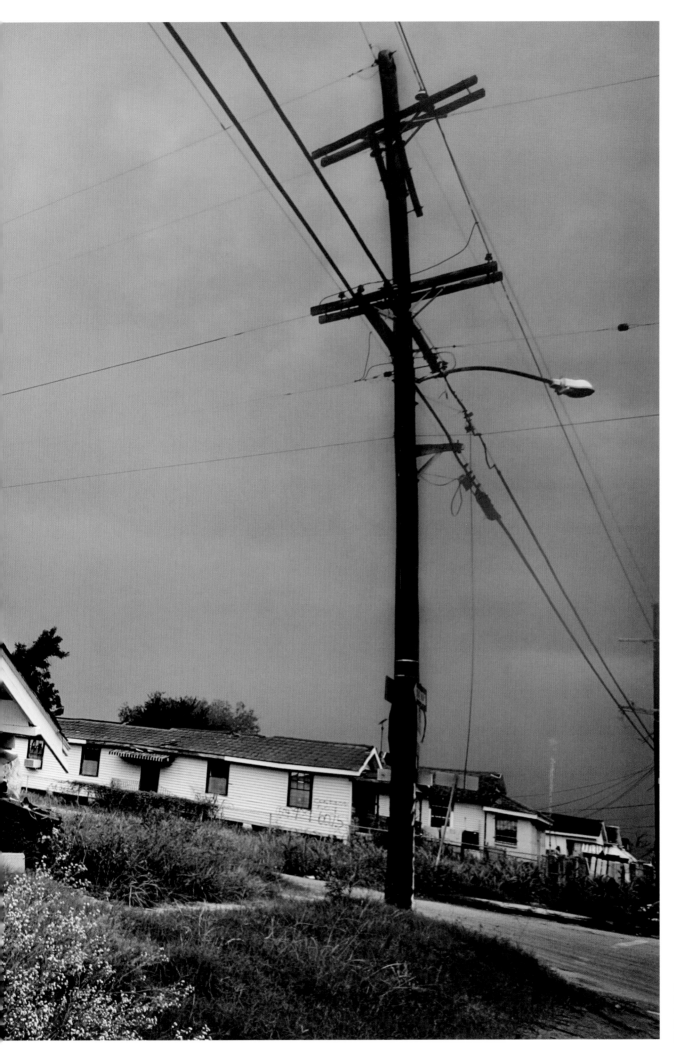

A lightning bolt strikes above a destroyed church in the Lower Ninth Ward, August 5, 2006, New Orleans.

A Mardi Gras mask caked in mud lies in the heavily damaged
Lower Ninth Ward in the aftermath of Hurricane Katrina,
September 9, 2005, New Orleans.

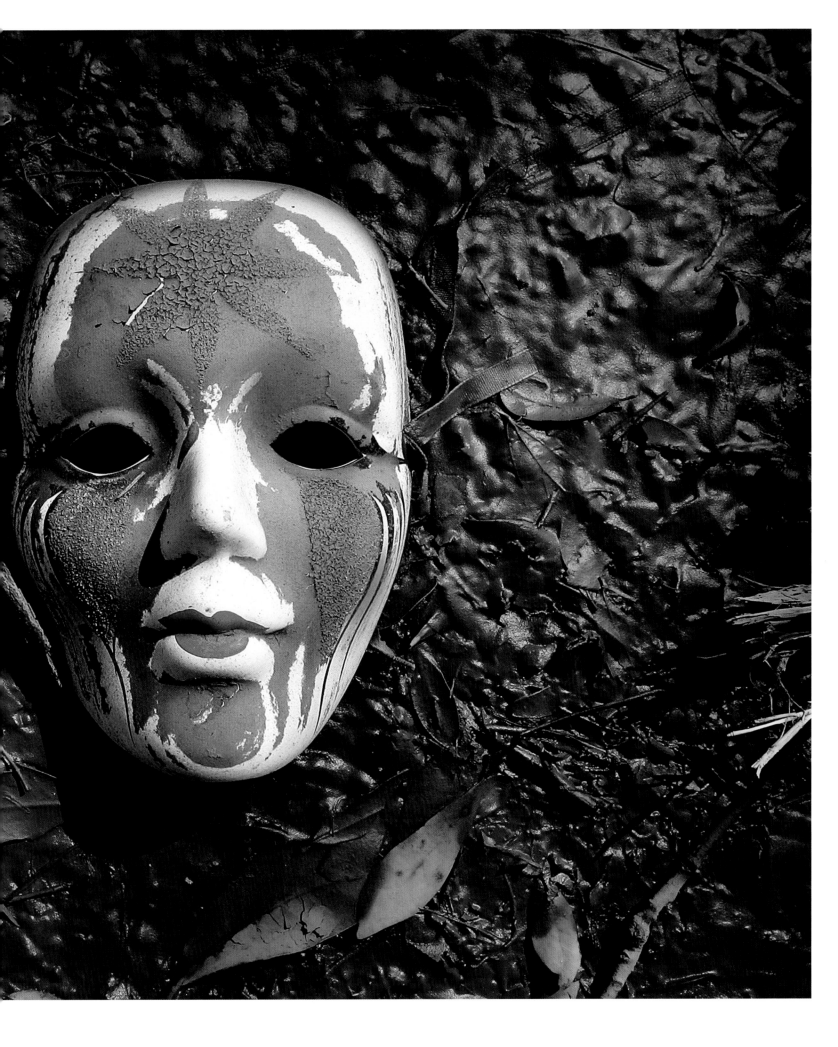

ARTIST STATEMENT
Mario Tama

I watched the twin towers fall in New York, where I live, and I saw Hurricane Katrina lay waste to New Orleans, which I now consider something like a second home. As horrific as 9/11 was, those of us fortunate enough to survive (2,752 perished in New York) were generally able to return home that evening and lie down in our beds. While fewer people perished in Katrina (at least 1,836), for those affected by it, home no longer existed. For some, it still doesn't. This book documents the worst natural disaster in modern American history and its aftermath of neglect and marginalization. More importantly, it chronicles the people of New Orleans and the surrounding areas in Louisiana and Mississippi, who refused to submit to the weight of the disaster and the negligence of the governmental apparatus to honor its obligations toward its citizens, and courageously decided to come back home.

Perhaps the might of the New Orleanians has something to do with their history. While New Orleans may be known as the Big Easy, the lives of its inhabitants have often been anything but. They have suffered wars, storms, slavery, epidemics of yellow fever and cholera, fires, riots, segregation, illiteracy, and endemic poverty. Yet from the roots of a scraggly French outpost built near the mouth of the mighty Mississippi has come a remarkable city which has generated America's first indigenous art form, jazz; cuisine admired the world over; magnificent colonial architecture; brilliant literature; and an inimitable multicultural society.

I will never forget the moment I realized I would follow this story as it moved from the despair of ruin to the recovery of everything that New Orleans was before the storm. It was May, 2006, about nine months after the storm, and the city was still devastated. I was searching for signs of a resurgence of pre-Katrina New Orleans, when a kind woman I met suggested that I check out the Original Big 7 Social Aid and Pleasure Club Second Line Parade. She gave me directions to an uncertain location somewhere along Frenchmen Street in the Seventh Ward. I had heard of second line parades only vaguely, but knew that they were somewhat secret affairs, known only to native New Orleanians. Arriving in the Seventh Ward, I spotted people lingering on their front porches and gathering along the street with coolers and grills.

In the distance I heard a beat, and a slowly gathering rhythm, a gaining sonance of brass and drums echoing down Frenchmen Street as a crowd materialized seemingly out of thin air. The music echoed through the faded but richly colored shotgun houses, many still marked with the writings of rescue workers who had searched the homes for survivors after the storm. The crowd suddenly exploded onto the streets as the Stooges Brass Band arrived, pounding their drums and blowing their horns in a vibrating, heart-thumping procession. Dancers leapt through the air and slid across the ground as the band improvised, bobbed and weaved its way through what was now an all-out flowing congregation. The Original Big 7 men, in full regalia of white (symbolizing rebirth and baptism) trousers, shirts, top hats and blue sashes around their shoulders, strutted along to the beat waving handkerchiefs and fans made of ostrich feathers. The women in the crowd were decked out in fine garments of outrageous colors. One particular group of sisters stood out from this sea of color with their beautiful red dresses and pink ribbons running through their hair. The resilience of the people of New Orleans had once again risen into the heart of the disaster and delivered its *devoir*: OVERCOME.

This was indeed the sign of resurgence that I had sought. The crowds that had gathered in the Seventh Ward that day in and around the Original Big 7 Second Line Parade were survivors of Katrina, who had come together in a ceremony of cultural and communal unity as they had done for centuries. The Original Big 7 was not just putting on a show but providing much-needed psychological and emotional solace to some of the most needy New Orleanians who were attempting to rebuild their homes and lives after Katrina. I learned later that second line parades, put on by various social aid and pleasure clubs organized by neighborhood, represent an entire history of economic, social and political empowerment, community solidarity and cultural pride within the African-American communities of New Orleans. The social aid and pleasure clubs provided financial, legal and neighborly assistance to their members, who were unable to access these services from the official administration. I had never seen bonds of community like this on display anywhere in the United States, and to witness it in the heart of post-Katrina New Orleans was nothing short of miraculous. It was like a jazz funeral for Katrina. Her body had been put in the ground and the people were parading on their way back home.

Edward Buckner, president of the Original Big 7, summed up the significance. "I was in Shreveport, Louisiana, and got up one Sunday morning, and got fully dressed about nine thirty, ten o'clock . I don't know where I thought I was, but thought I was in New Orleans. And I prepared myself, I was fully dressed and wearing all black and white, and I realized, 'You're not home. There's no parade today, there's no bands, there's none of that today.' So I ended up taking all the clothes off, after I shaved and everything. And I had to sit down and do nothing. And that's when I knew for sure that I was coming home right away...All of the members were sprayed all over America, we had guys in Atlanta, we had guys in Arkansas, we had guys in Shreveport, we had guys everywhere. They said, 'Get it together and we're ready to go.' So I got it together and we were ready to go. Just doing the parade inspired a lot of people to come home."

I followed Buckner and the rest of the Big 7 procession throughout the day as they weaved their way through the once-flooded homes of the Seventh Ward, in times gone by considered the quintessential Creole neighborhood of New Orleans. I kept thinking to myself, "Who is in control?" That is a question one can never answer in New Orleans. Because no one is. No one controls the music. No one controls the streets. No one controls the parades. No one controls the social life that extends from day into night and from night into dawn. And no one controls the river and the levees. . . .

Who is in control? I suppose most would say that God is in control. Three out of four Louisianans say that they pray every day. When Katrina came and left its ebb tide of horror and misery, most survivors I spoke with thanked God in one way or another. "If it wasn't for the Lord," said Willie McCrae, "we wouldn't have been here. . . . I was looking through that window, I was looking out at how that storm was blowing and how that rain was boiling and I just said to myself, 'I know He's on our side.'" Hazzert Gillett told me, "When that window blew out. . . some gashes of wind came and I literally saw that porch sway. All these ceiling fans they started shaking like that, the whole house, this house could have went down. But there was someone in here for God. He took care of his children. . . . It's just the grace of God that has us here today." And Yashakia Charles said, "I got my kids out through all that water, I broke my icebox, I put them three inside like a boat. We (swam) across the street, remember I don't know how to swim. I had a lifejacket on, but we made it. . . God is good. . . . He said 'Be patient my child, I'll be there.'"

They trusted in God—but the political structure failed them. What disturbed me the most in all the hindsight, spinning of facts, and assignation of blame after Katrina was the insinuation that the people of New

Orleans somehow deserved their fate. That because they, their relatives, and their ancestors had survived and thrived in this incredible city for close to three hundred years, it was somehow their negligence for living below sea level and believing in levees as a defense. One half of the entire country of the Netherlands lies below sea level, protected by levees, but the Dutch have gotten along just fine. New Orleanians could and did ride out the storm, but they could not withstand the corruption that caused the levees to fail and the incompetence of the agencies that were supposed to help them reach safety (with the notable exceptions of the U.S. Coast Guard and the Louisiana Department of Wildlife and Fisheries). Forty-six percent of poor households in New Orleans did not have access to an automobile and relied on public transportation. Bus services were supposed to be provided for the evacuation of people in the affected areas, but the buses never came. The poorest of New Orleans got stuck in the collapsed city and the ineffectiveness of FEMA and other responsible organizations kept them in conditions utterly unacceptable in this famously "heav'n rescued" land.

But some rescuers did come. On that day in New Orleans when the Original Big 7 Second Line paraded, thousands of volunteers from all over the world were handing out food, clothing, and loving kindness to Katrina survivors housed in tents and trailers scattered in New Orleans and throughout Louisiana, Mississippi and Alabama. Although the recovery of New Orleans is far from complete, the generous efforts of these people, combined with the incredible familial and community bonds of New Orleanians, helped the city to come back. I feel privileged to have been a witness to this feat of faith and courage in overcoming seemingly insurmountable odds. I saw them being wiped away from their homes, and I saw them return. I saw their lives and worldly possessions reduced to rubble, and I saw them collect that rubble and rebuild it piece by piece. Nobody told them to do this—certainly the government didn't. They just did it, with heart and mind and sinew and often-joyful determination. Perhaps that is what makes New Orleans extraordinary. New Orleans is that which America is supposed to be, a place of true freedom and faith. The city still has a long way to go, with the population currently approaching only 80 percent of pre-Katrina levels. According to the New Orleans Redevelopment Authority, 60,000 blighted or abandoned properties continue to mar the landscape.

Having survived a brush with extinction, this old city is also young, forward-looking, a laboratory for the reinvention of cities everywhere. For me, there was something wonderful in the discovery that New Orleans' most ambitious and successful strategy since Katrina has been a commitment to young people through the radical overhaul of the city's public schools. Once a national embarrassment, New Orleans schools are now reaching impressive new levels of achievement, independence, and accountability. The children pictured on these pages—every one of them—now have access to an open-enrollment charter school. In a city where most schools were failing, the majority are now succeeding after reforms accelerated by Katrina. There is a long road ahead for public schools in New Orleans—and every other big city. But New Orleans is leading the way.

A word about the photographs. This book focuses on the African-American victims of Katrina. This was not a conscious decision. As a photojournalist my task is to always document those who are the most severely affected. In this storm, without a doubt, people of every social and racial category were devastated. However, in New Orleans, those most often stranded, those most often without a means to evacuate, those most often without insurance and the funds to rebuild were African-Americans. In the historical context of New Orleans this is not surprising. African-Americans constituted approximately 67 percent of the city's population. I apologize to those who may feel neglected by my coverage. The scale of the event was such that no single person could possibly document all aspects of it. Katrina forced more than one million Americans into exodus, making it the largest American mass migration since the Dust Bowl. It was impossible to document all their stories. I focused on telling some stories, those available to me, in the hope that they would speak for all.

These images are reflections of the struggle to rebuild lives devastated by Katrina, as well as of the histories embodied in the faces, traditions and communities I encountered. Walking into New Orleans is stepping into history, where the spirits of Native American, Spanish, French, African, Cajun, Italian, Caribbean, Irish, Jewish, German and Creole pasts are evident in every corner. It is a city whose people carry a vigorous and rarified strand of the very DNA of the American experience. This essay is an homage to the people I met, to the history they represent. Above all it is an homage to those whose faith, courage and determination were an inspiration to me and I hope will be an inspiration to us all.

This book is dedicated to the courageous people of New Orleans and the surrounding areas who welcomed me into their tents, their trailers, their homes, and their hearts.

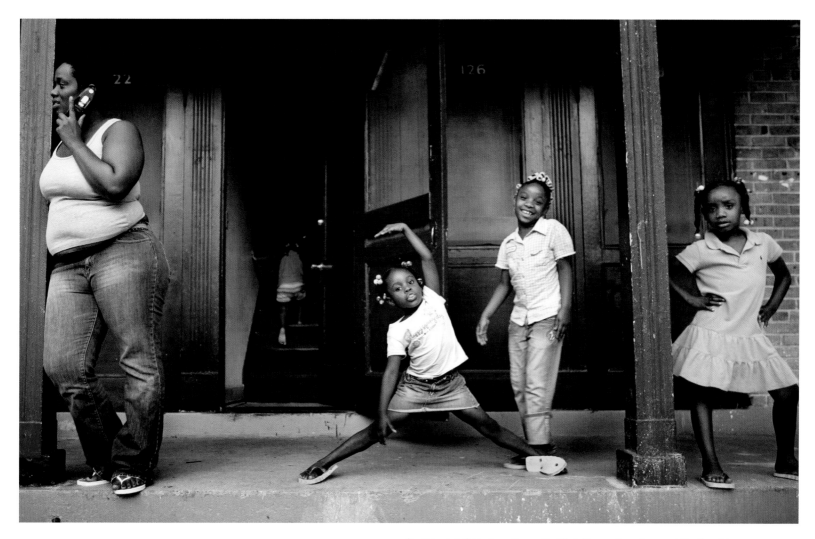

(Left to right) Mother Alvera Smith talks on the phone while daughters Aaliyah, Corlia, Kayla, and Kaylen Smith gather in the B.W. Cooper housing project, June 13, 2007, New Orleans.

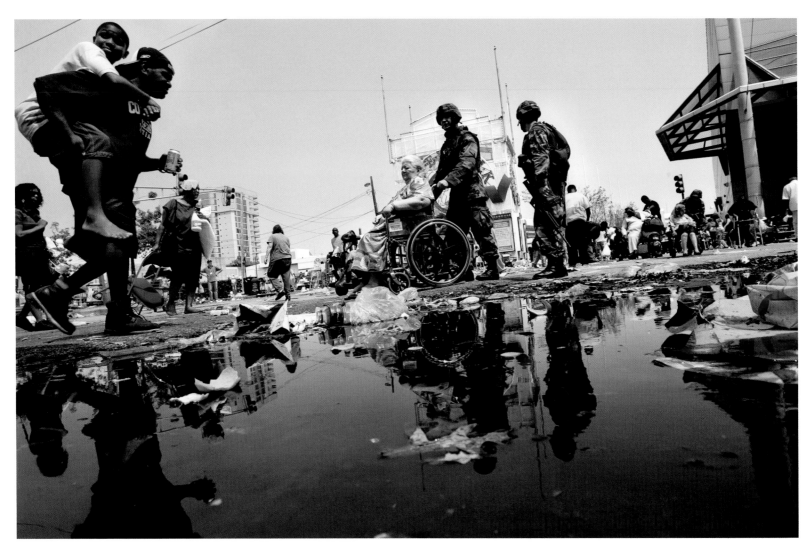

U.S. Army National Guard soldiers assist stranded victims of Hurricane Katrina outside the Ernest N. Morial Convention Center, September 2, 2005, New Orleans.

"We all live in a house on fire, no fire department to call; no way out, just the upstairs window to look out of while the fire burns the house down with us trapped, locked in it."

—TENNESSEE WILLIAMS
The Milk Train Doesn't Stop Here Anymore

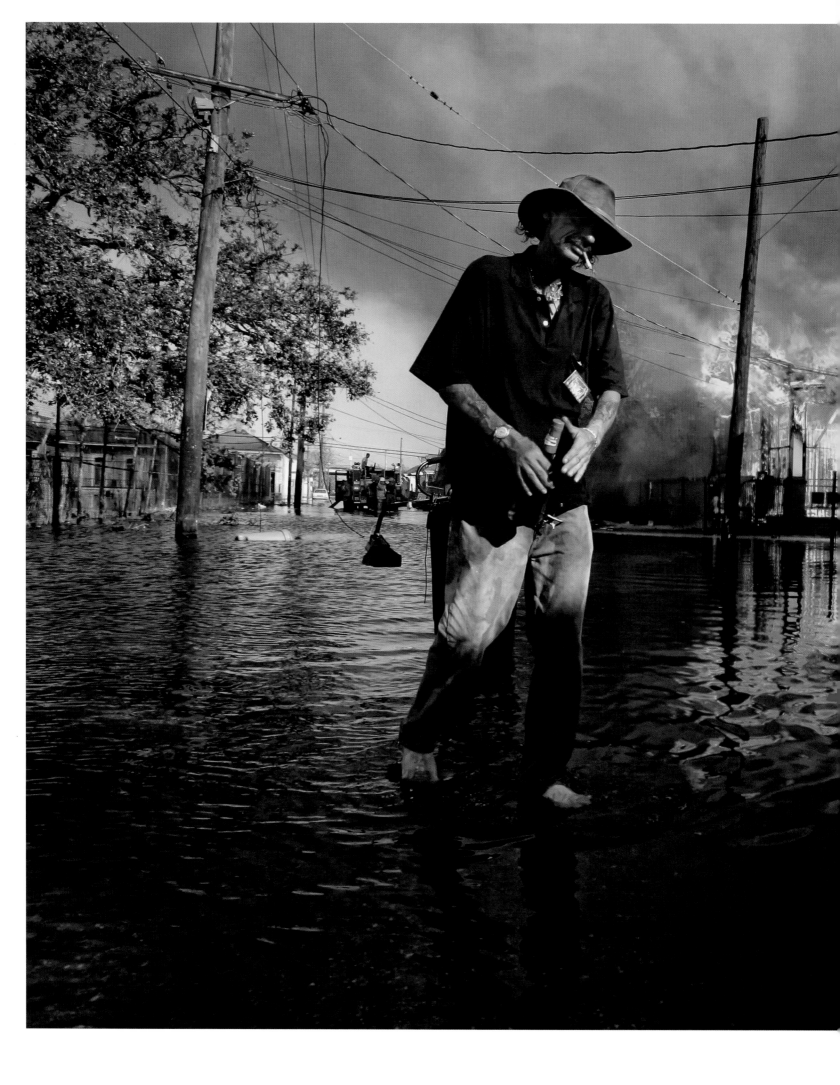

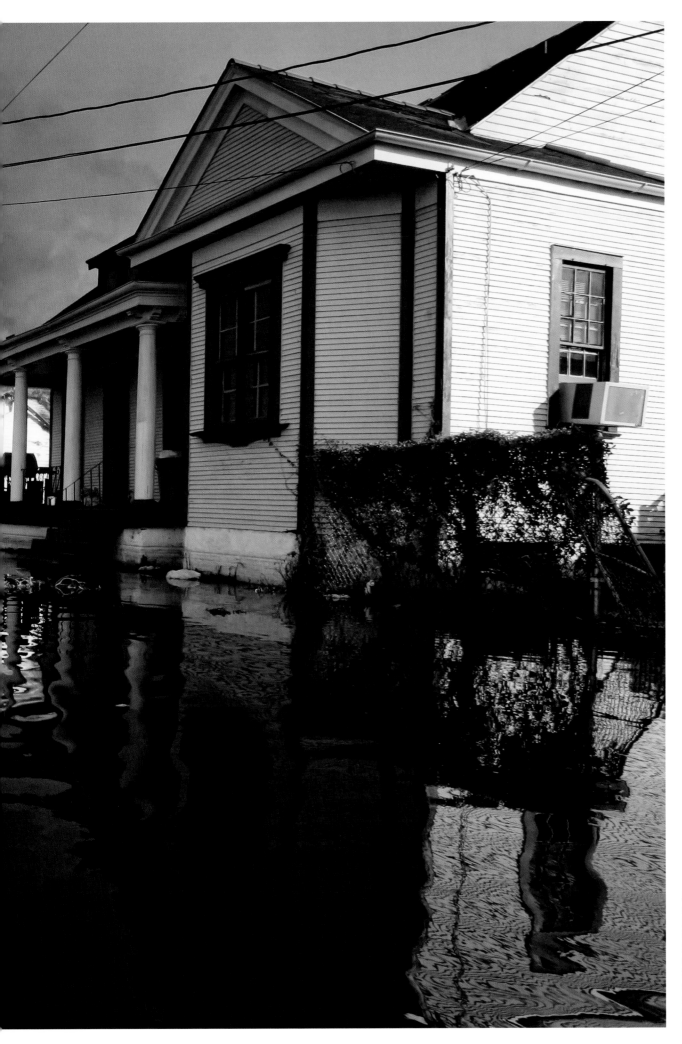

A resident walks past a burning house fire in the Seventh Ward, September 6, 2005, New Orleans. Fire companies struggled to combat fires in the city with unreliable water pressure and communications difficulties.

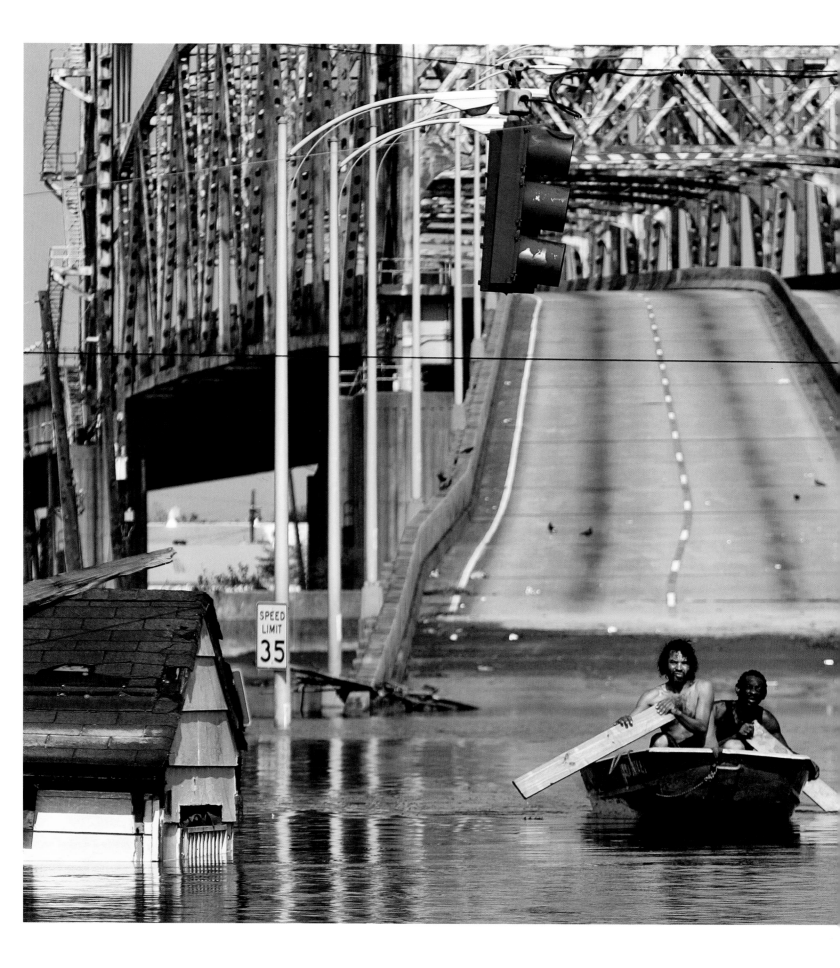

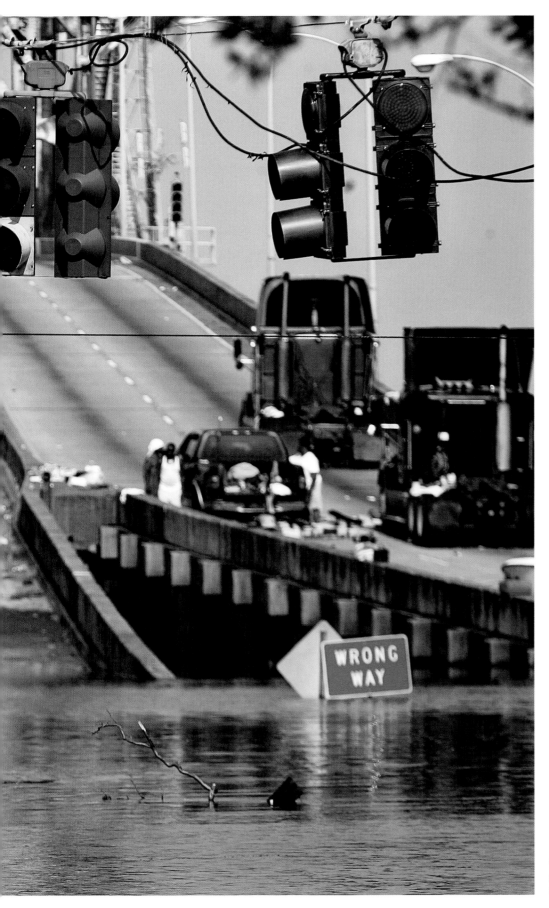

"Ten thousand River Commissions, with the mines of the world at their back, cannot tame that lawless stream, cannot curb it or confine it, cannot say to it, Go here, or Go there, and make it obey; cannot save a shore which it has sentenced; cannot bar its path with an obstruction which it will not tear down, dance over and laugh at."

—MARK TWAIN
Life on the Mississippi

Two men paddle in high water after Hurricane Katrina devastated the area, August 31, 2005, New Orleans.

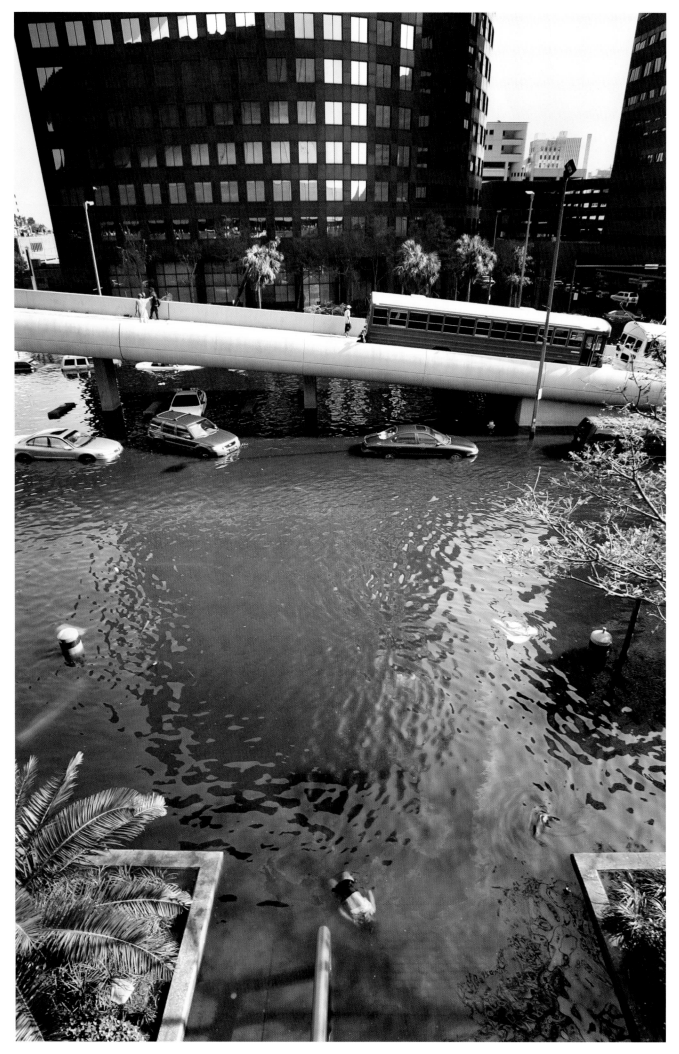

The dead body of a female victim of Hurricane Katrina floats in the water surrounding the Superdome, September 2, 2005, New Orleans.

"Considering the dire circumstances that we have in New Orleans, virtually a city that has been destroyed, things are going relatively well."

—FEMA DIRECTOR MICHAEL BROWN,
September 1, 2005

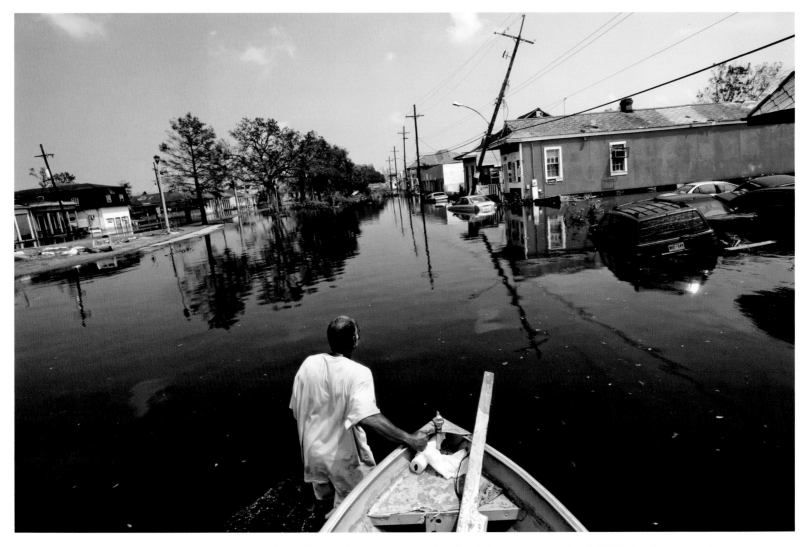

Ira Jackson pulls his boat through a flooded street, September 5, 2005, New Orleans. Jackson used the boat to bring fresh water to his house and to others in his community.

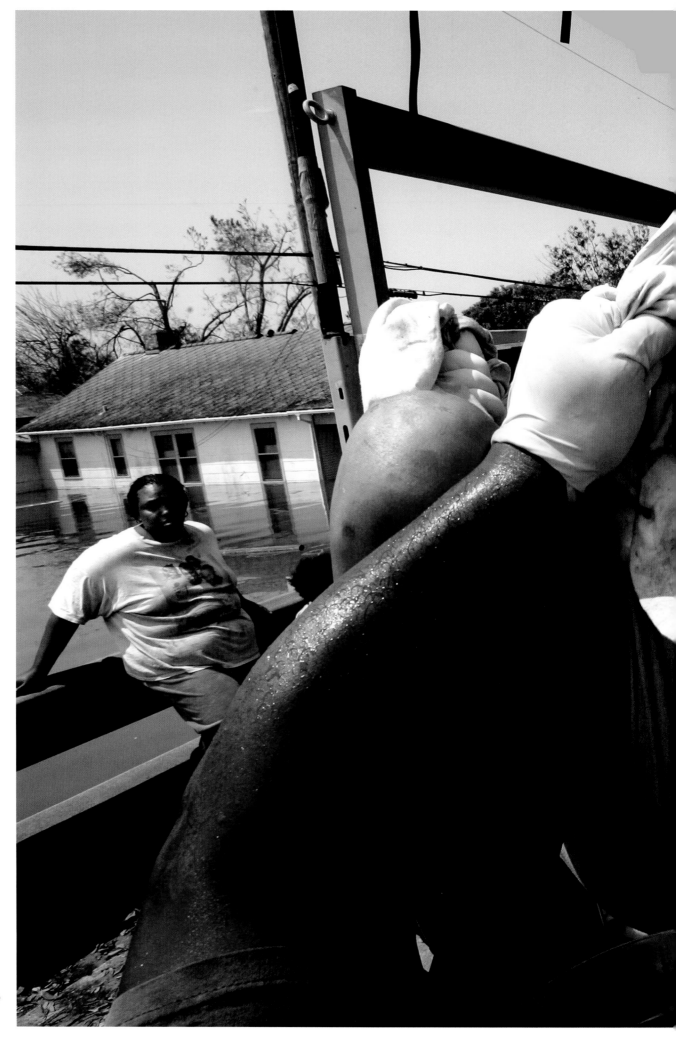

A woman is placed into an Army vehicle after being rescued from her home in high water in the Lower Ninth Ward during the aftermath of Hurricane Katrina, August 30, 2005, New Orleans.

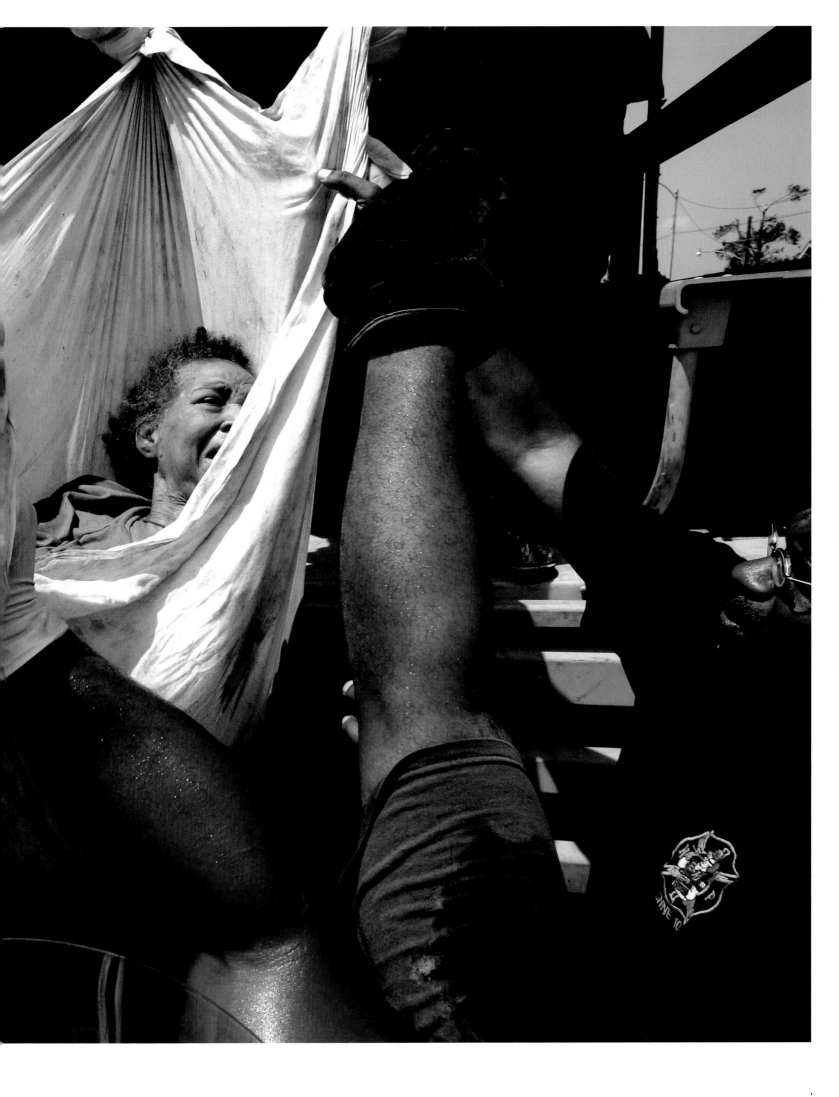

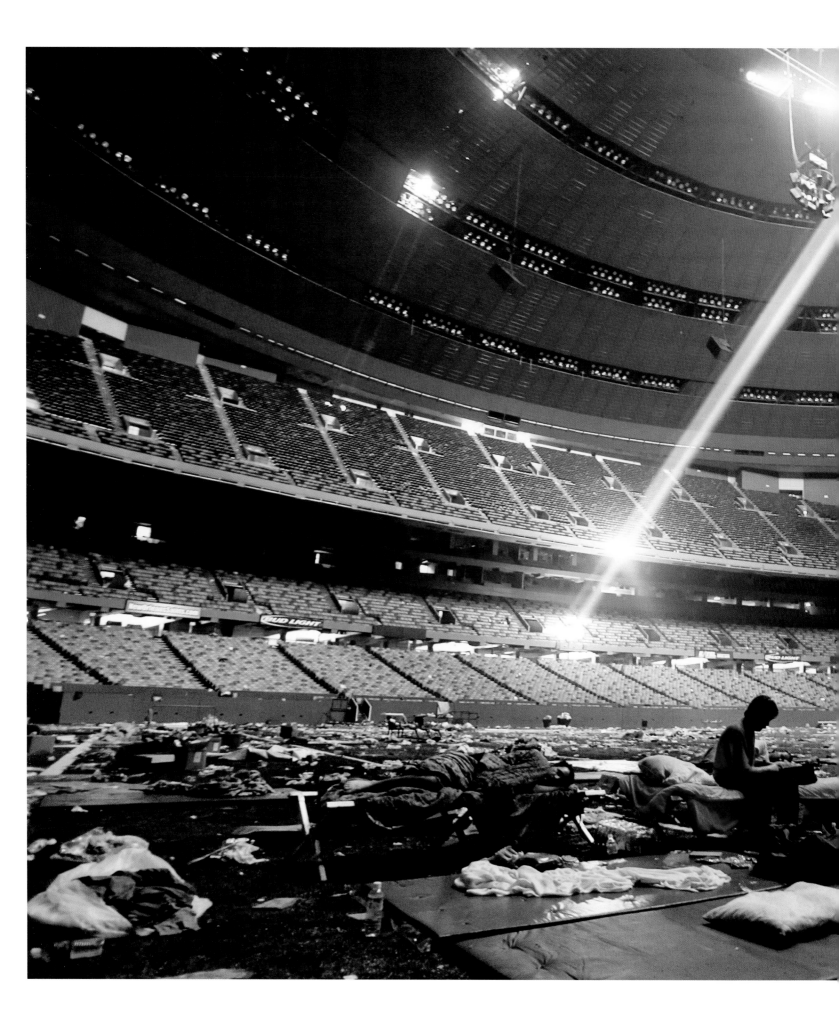

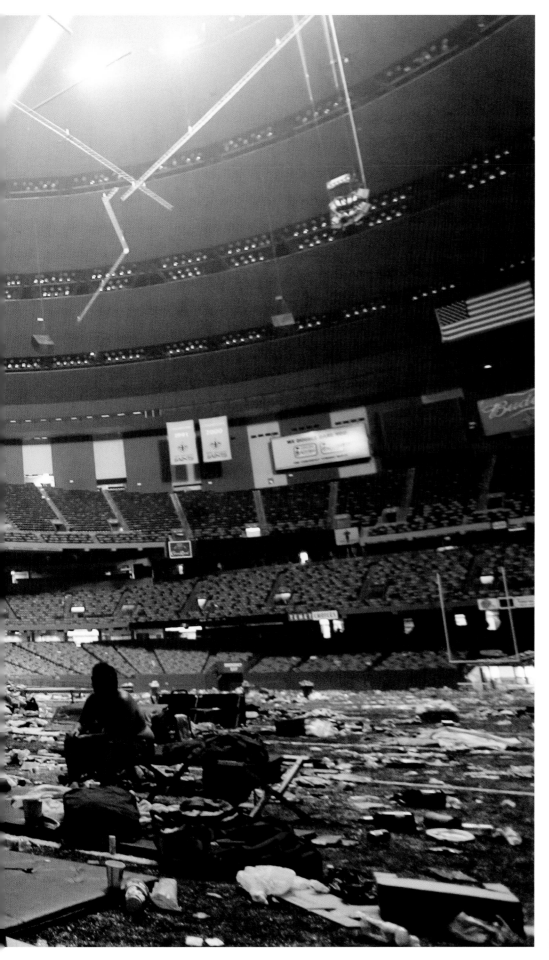

"What, other than injustice, could be the reason that the displaced citizens of New Orleans cannot be accommodated by the richest nation in the world?"

—WYNTON MARSALIS
*Tulane University,
January 16, 2006*

Stranded survivors wait in the Superdome, September 1, 2005, New Orleans.

"No war, no storm, no unitedness of these states can destroy me. I am a survivor. I may be forever. I am Creole. I am New Orleans."

—ROY F. GUSTE JR.
"I Am Creole"

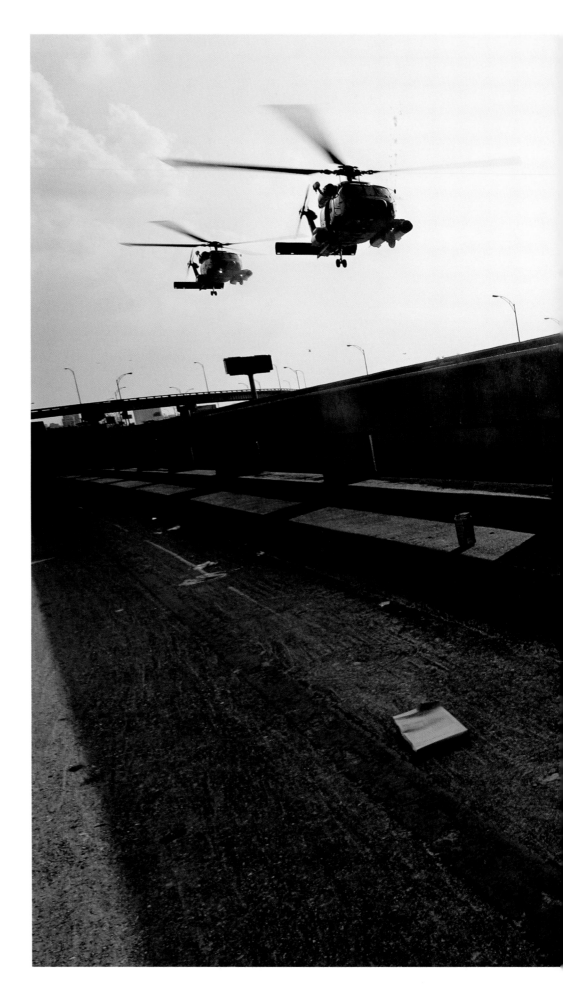

Eugene Green holds his son Eugene Green Jr. as they wait with other stranded victims of Hurricane Katrina to be airlifted by helicopter from a highway overpass, September 4, 2005, New Orleans.

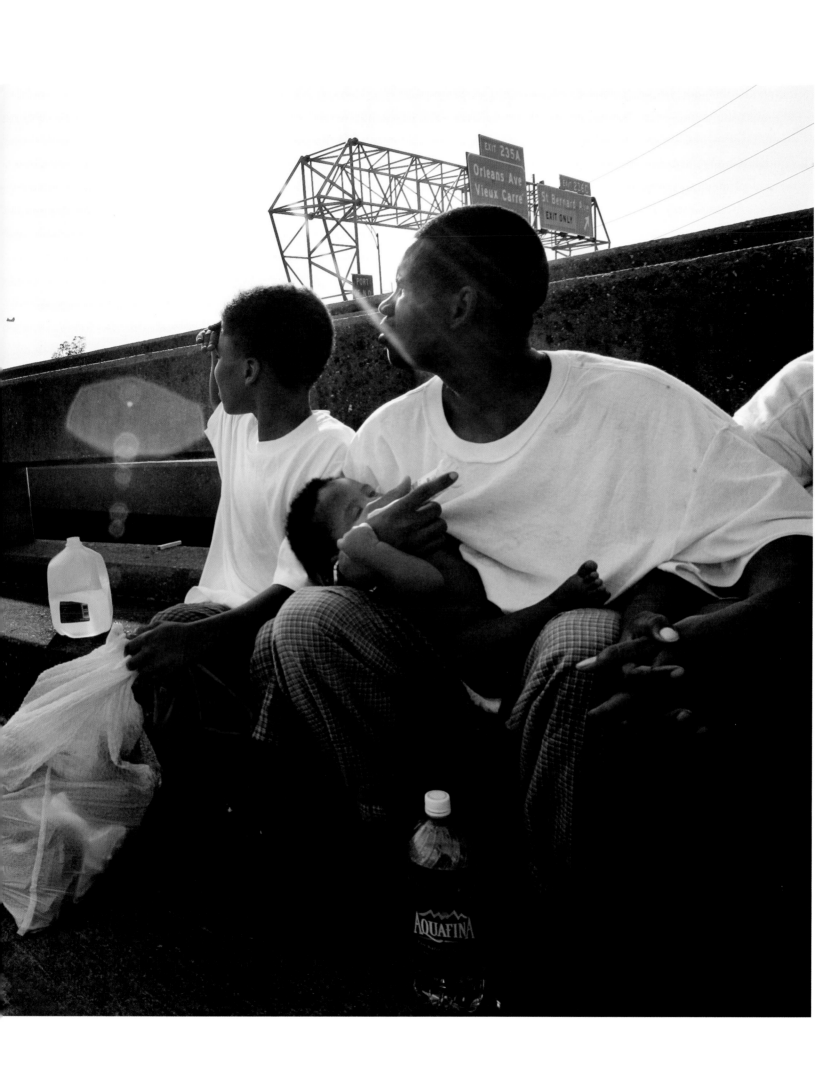

33

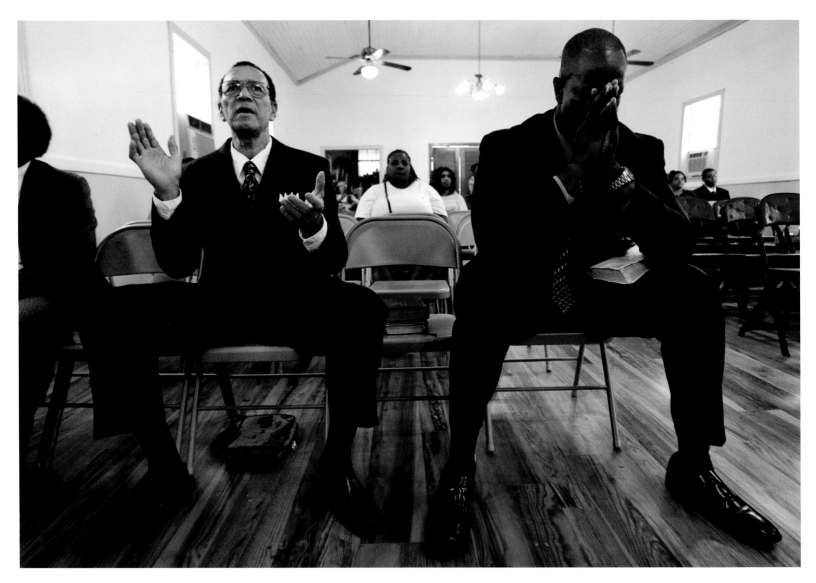

Hazzert Gillett sings as another worshiper prays during services at Greater Little Zion Missionary Baptist Church, which was founded in 1900, in the Lower Ninth Ward, August 26, 2007, New Orleans. The church was flooded by Hurricane Katrina but has since reopened.

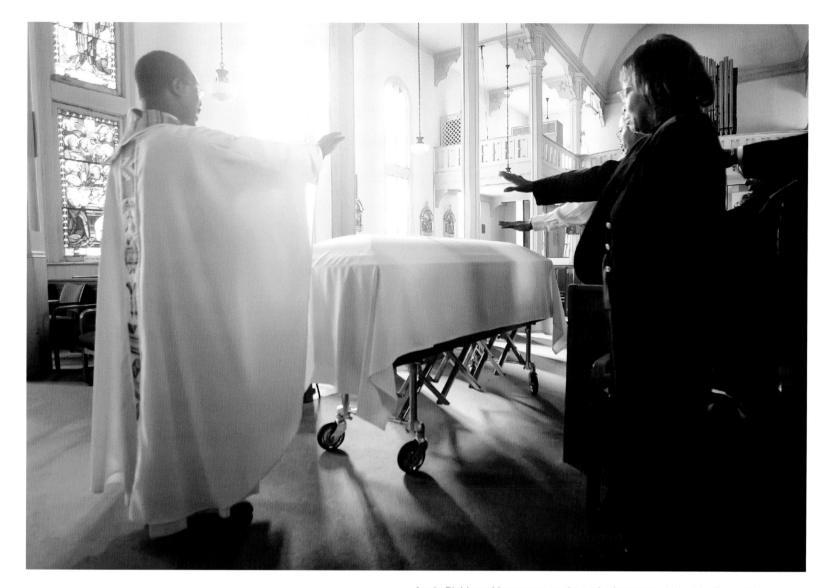

Annie Richburg (r) gestures as she and others pray during the funeral for her husband, Lejohn Richburg Jr., at St. Francis De Sales Catholic Church, November 23, 2005, New Orleans. The Richburgs attempted to evacuate New Orleans prior to the storm, but Lejohn's weak leg prevented them from doing so, according to the family. As the floodwaters rose on August 29, they fled to their attic, where Lejohn Richburg drowned after falling from his wife's arms into the water in the stairwell. Annie was later rescued by helicopter.

"My New Orleans is all about us, her people. We move it and shake it a little bit more down here, you know, and a lot better. . . and our faith is stronger."

—CHARMAINE NEVILLE
 "Come as You Are"

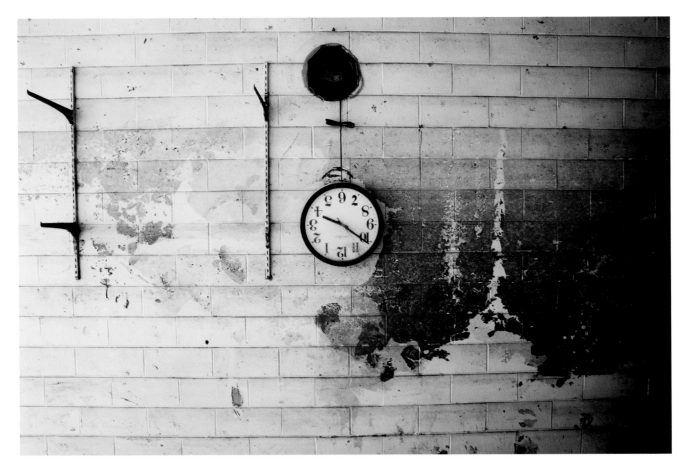

A clock hangs upside down inside the heavily damaged Lawless High School in the Lower Ninth Ward, August 28, 2007, New Orleans.

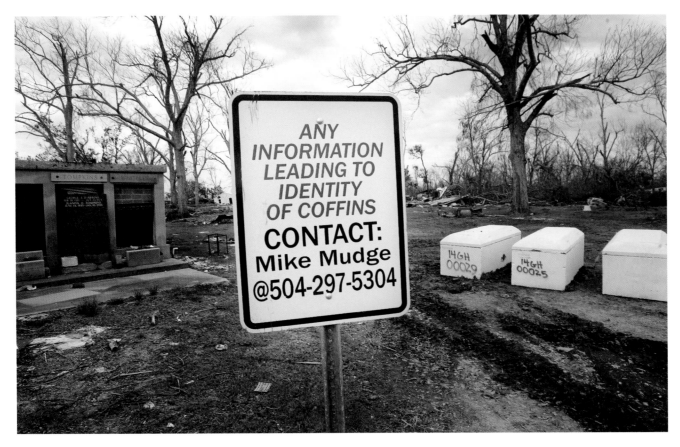

A sign asking for information about unidentified coffins at an above-ground cemetery, February 23, 2006, Buras, Louisiana. The cemetery was flooded during Hurricane Katrina, causing a number of coffins to float away from their crypts.

"But the people cannot have wells, and so they take rain-water. Neither can they conveniently have cellars or graves, the town being built upon 'made ground'; so they do without both, and few of the living complain, and none of the others."

—MARK TWAIN
Life on the Mississippi

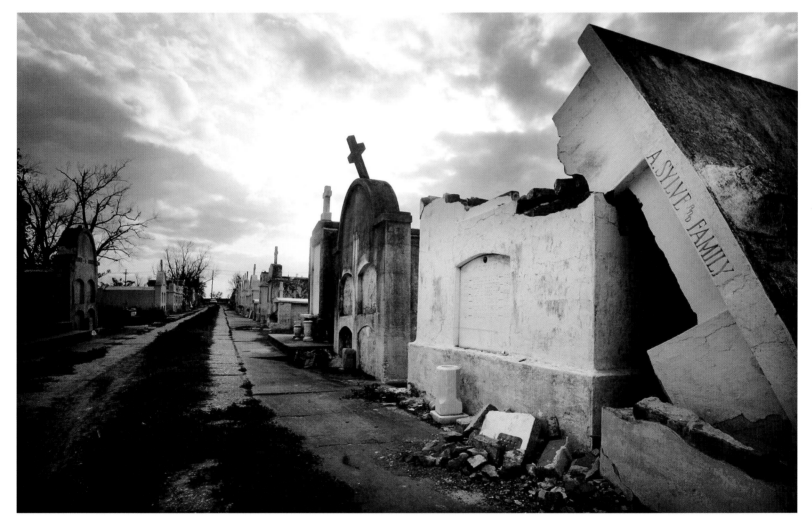

A destroyed crypt at an above-ground cemetery, February 23, 2006, Buras, Louisiana.

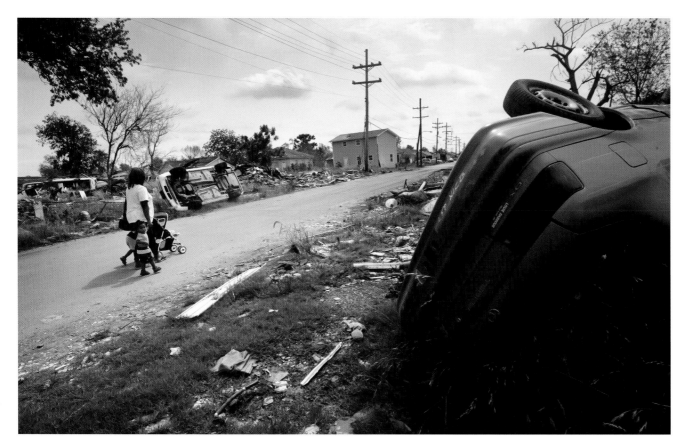

Shanika Reaux walks through the devastated Lower Ninth Ward on her way to a bus stop with her children, May 10, 2006, New Orleans. Reaux said she moved into a donated gutted home in the Lower Ninth Ward in February, 2006, after FEMA would no longer pay for her housing once she returned to the state of Louisiana. The water in the area was unsafe to drink and many homes were completely destroyed.

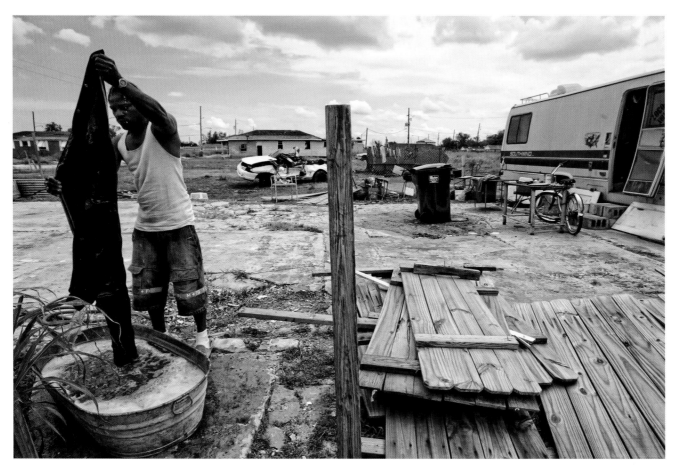

Lonnie Kent washes his clothes in a tub in front of the old motor home he uses as his residence in the Lower Ninth Ward, May 28, 2007, New Orleans. Kent's home was destroyed by the flooding following Hurricane Katrina. He said he had not been able to acquire a FEMA trailer, forcing him to live in the motor home, which had no electricity or gas.

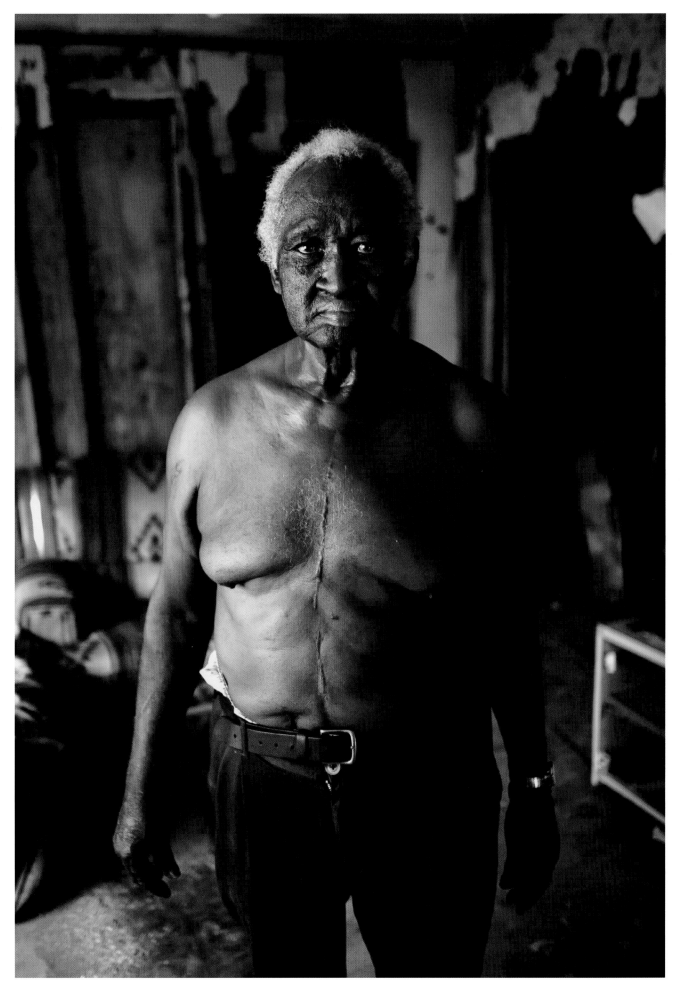

Willi Lee, 79, stands inside his home, which he hopes to rebuild, May 25, 2006, Pearlington, Mississippi. Lee said he attempted to ride the storm out in the house but eventually was washed outside by the flooding, where he was able to cling to a tree limb for hours until the floodwater subsided. A poisonous water moccasin snake clung to the limb next to him the entire time. The eye of Hurricane Katrina passed directly over Pearlington, located approximately midway between New Orleans and Biloxi, Mississippi.

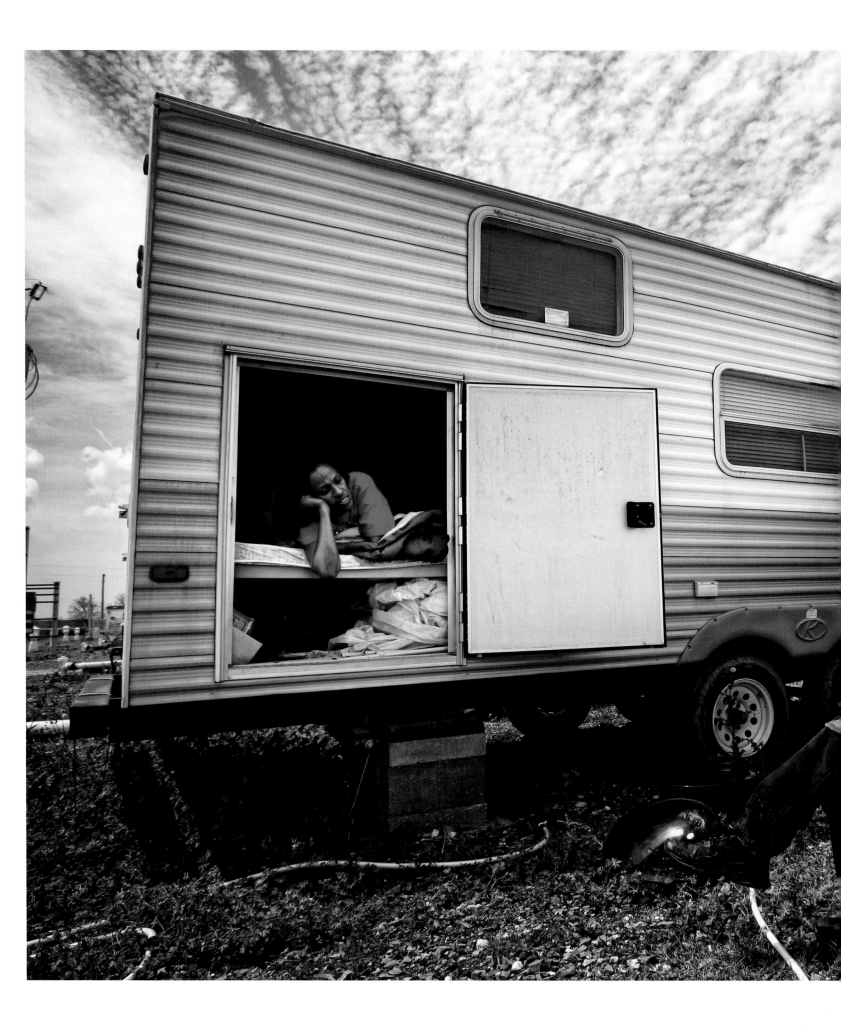

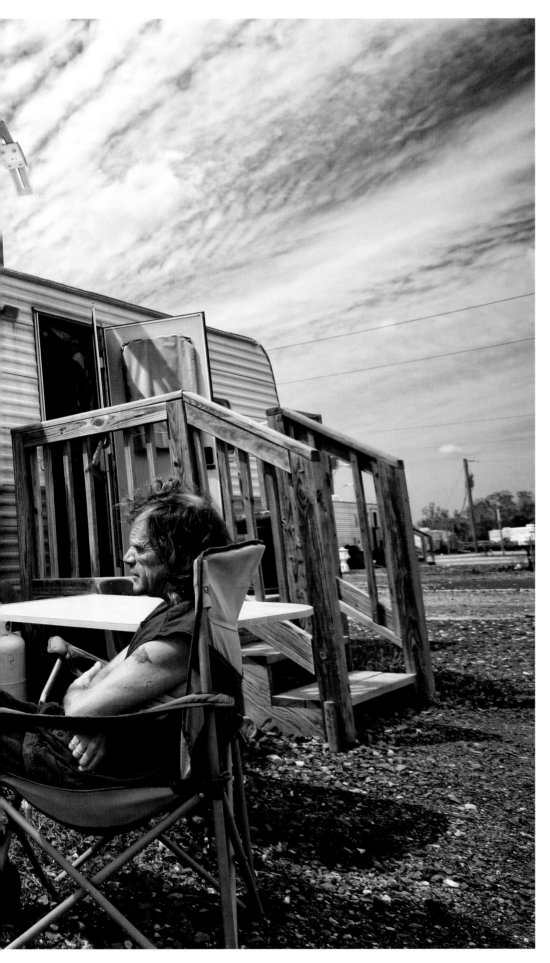

"The black, the white, and the lovely Creole blends of all; the silk-stockinged rich, the poor, and the in-between; the native and the newcomer. . ."

—ROSEMARY JAMES
"New Orleans Is a Pousse-Café"

Catherine Dean sits on her makeshift bed in a FEMA trailer she shares with Harvey Tribe in the FEMA Diamond travel trailer park, March 22, 2008, Port Sulphur, Louisiana.

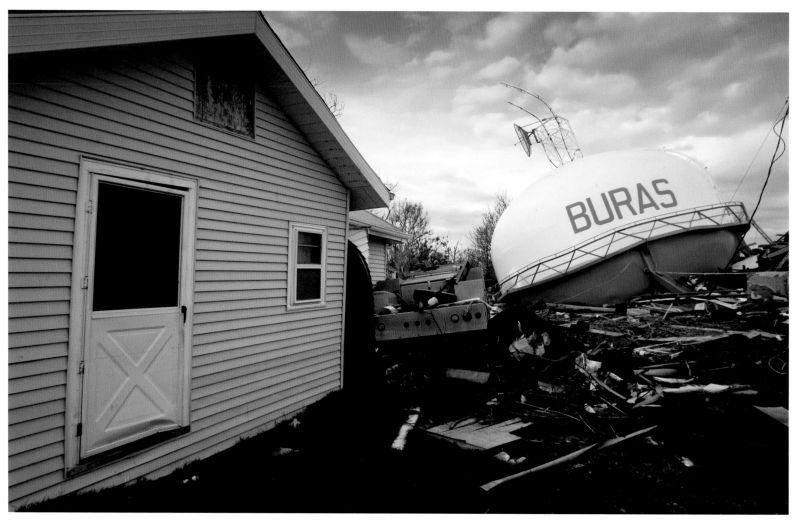

A destroyed water tower and home, February 23, 2006, Buras, Louisiana.

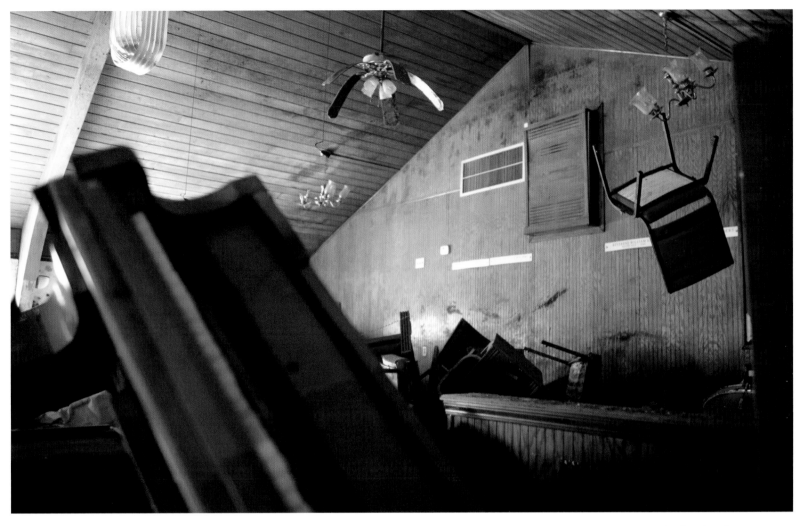

A chair hangs from a light fixture in a destroyed church after flooding in the Lower Ninth Ward, May 30, 2006, New Orleans. Hurricane Katrina destroyed dozens of churches in the Lower Ninth Ward.

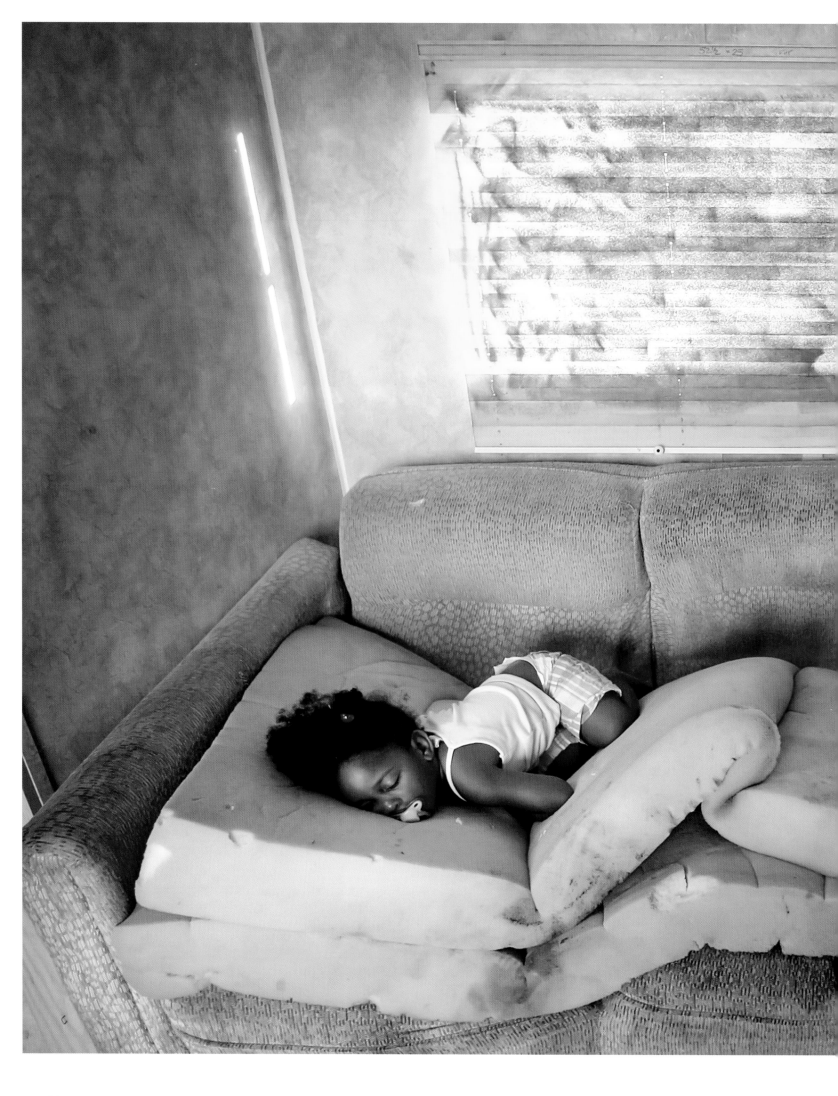

Kailah Smith, 18 months, sleeps on a couch covered in mold caused by rain leaks in her parents' FEMA trailer, just before the family moved out of the trailer to an apartment, May 28, 2008, Port Sulphur, Louisiana. Smith's parents had to hospitalize her with bronchitis four times since they moved into the trailer and they said they were sure the trailer was to blame for her illnesses. Doctors fear tens of thousands of children were exposed to dangerous levels of the cancer-causing agent formaldehyde in the post-Katrina FEMA trailers and could have lifelong illnesses.

45

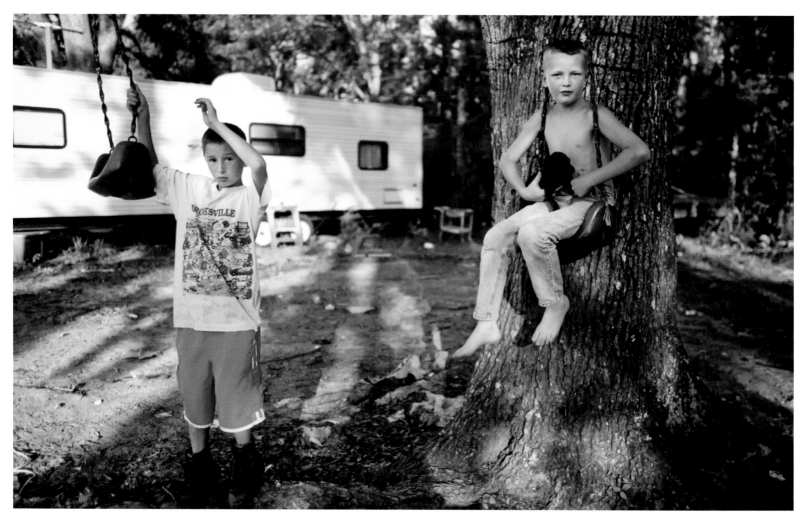

Nathaniel Dawsy (r) sits on a swing as Kaiser West stands by, May 25, 2006, Pearlington, Mississippi.

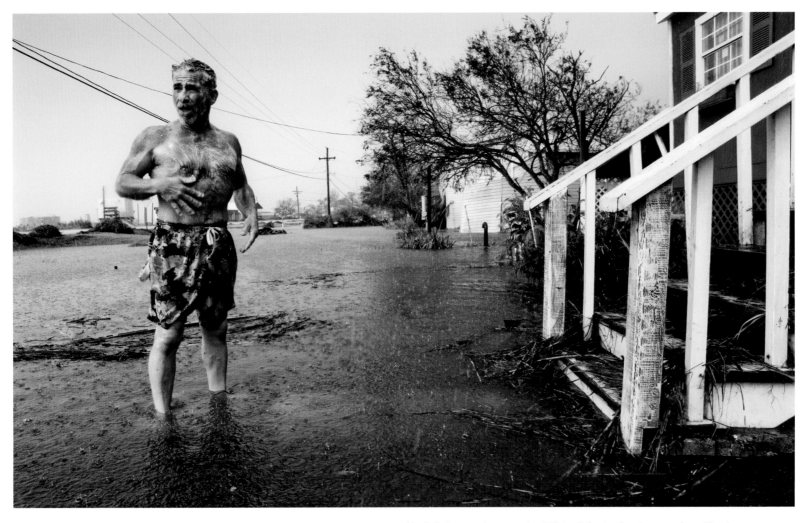

Mark Colwart takes a makeshift bath in the floodwaters from Hurricane Gustav in front of his home, September 2, 2008, Chauvin, Louisiana. Colwart said running water wasn't functioning in the area due to the storm. Chauvin is located just north of Cocodrie, near where the eye of Hurricane Gustav made landfall.

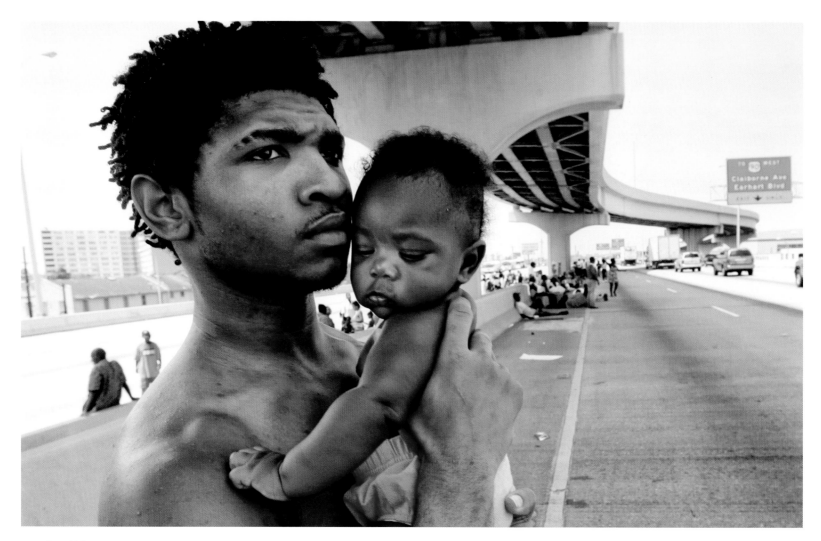

Daryl Thompson holds his daughter, Dejanae, three months, as they wait with other displaced residents on a highway in the hopes of catching a ride out of town after Hurricane Katrina, August 31, 2005, New Orleans. Thompson and thousands of others were looking for a place to go after leaving the Superdome shelter.

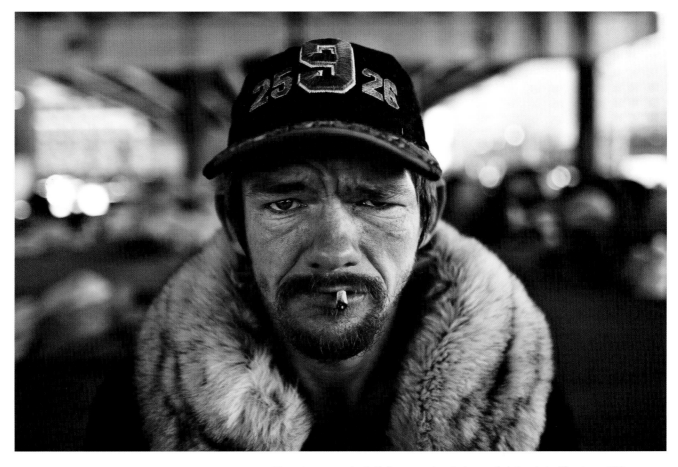

Homeless man Jack Halterman stands beneath Interstate 10, where 100 people sleep each night, December 16, 2007, New Orleans. Affordable housing stocks have dwindled, with rents rising 40 percent following Hurricane Katrina.

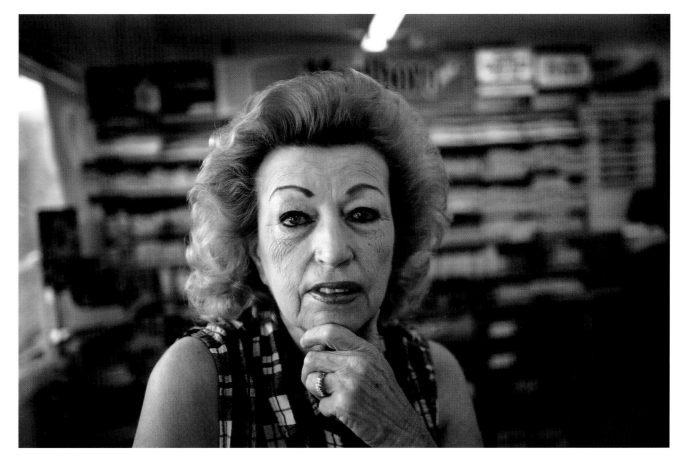

Mary Hillhouse, whose Pearlington home was destroyed by Hurricane Katrina in 2005, works behind the counter at a market on the official first day of hurricane season, June 1, 2007, Pearlington, Mississippi.

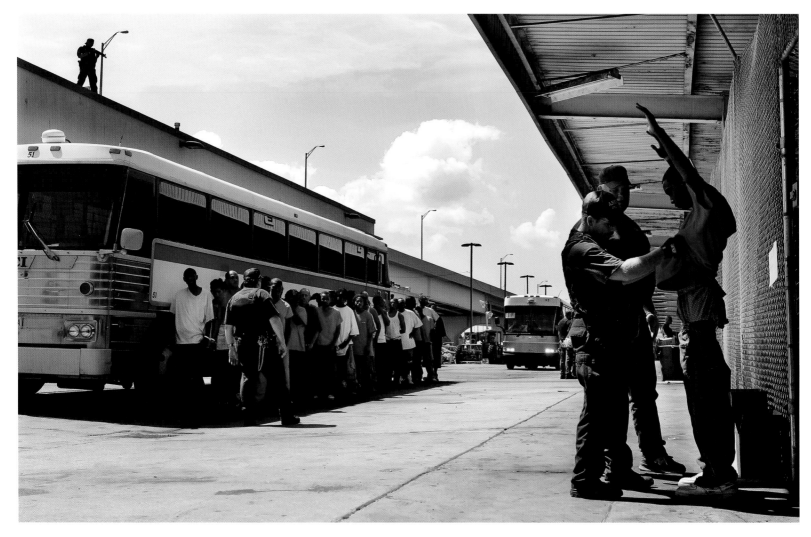

Corrections officers search an inmate at a temporary prison inside a
Greyhound bus terminal, September 6, 2005, New Orleans. About 150
inmates accused of crimes in the aftermath of Hurricane Katrina were
held at the makeshift prison.

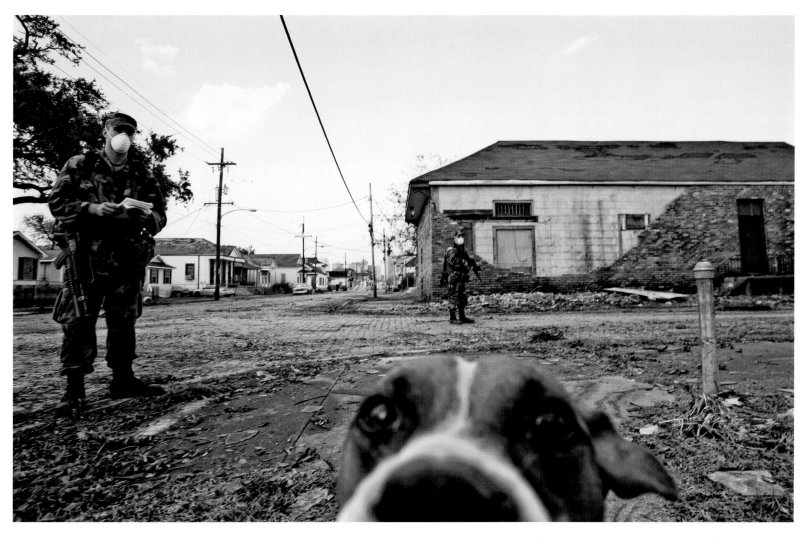

A stray dog walks with U.S. Army National Guard soldiers from Oklahoma conducting door-to-door searches, September 12, 2005, New Orleans. Thousands of dogs were abandoned or stranded in the city without their owners following the hurricane.

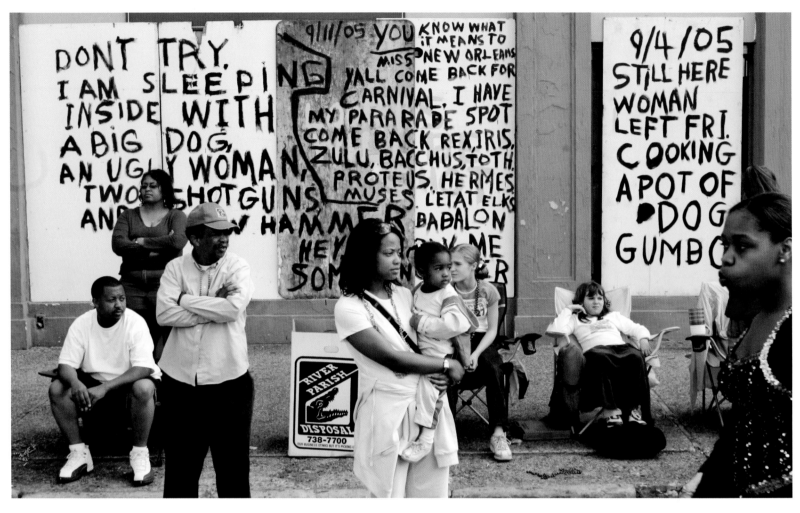

Onlookers wait for a Mardi Gras parade float in front of graffiti written during the Hurricane Katrina aftermath, February 25, 2006, New Orleans.

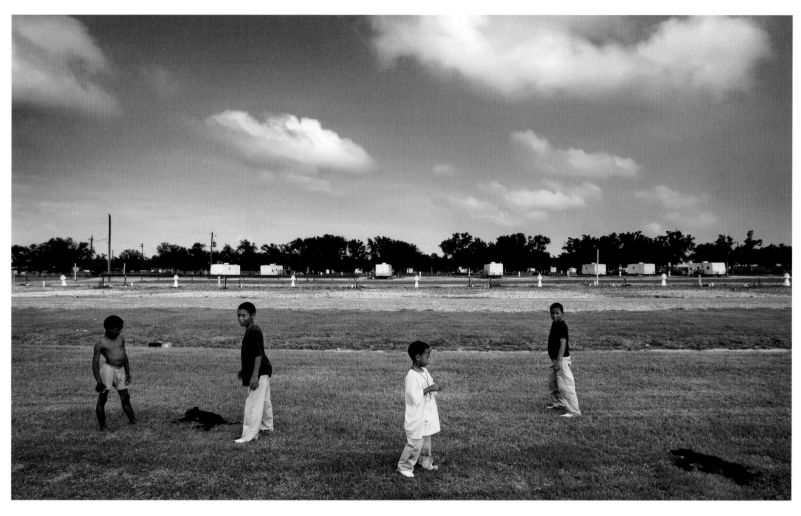

Boys play with dogs in the FEMA Diamond travel trailer park, May 23, 2008, Port Sulphur, Louisiana.

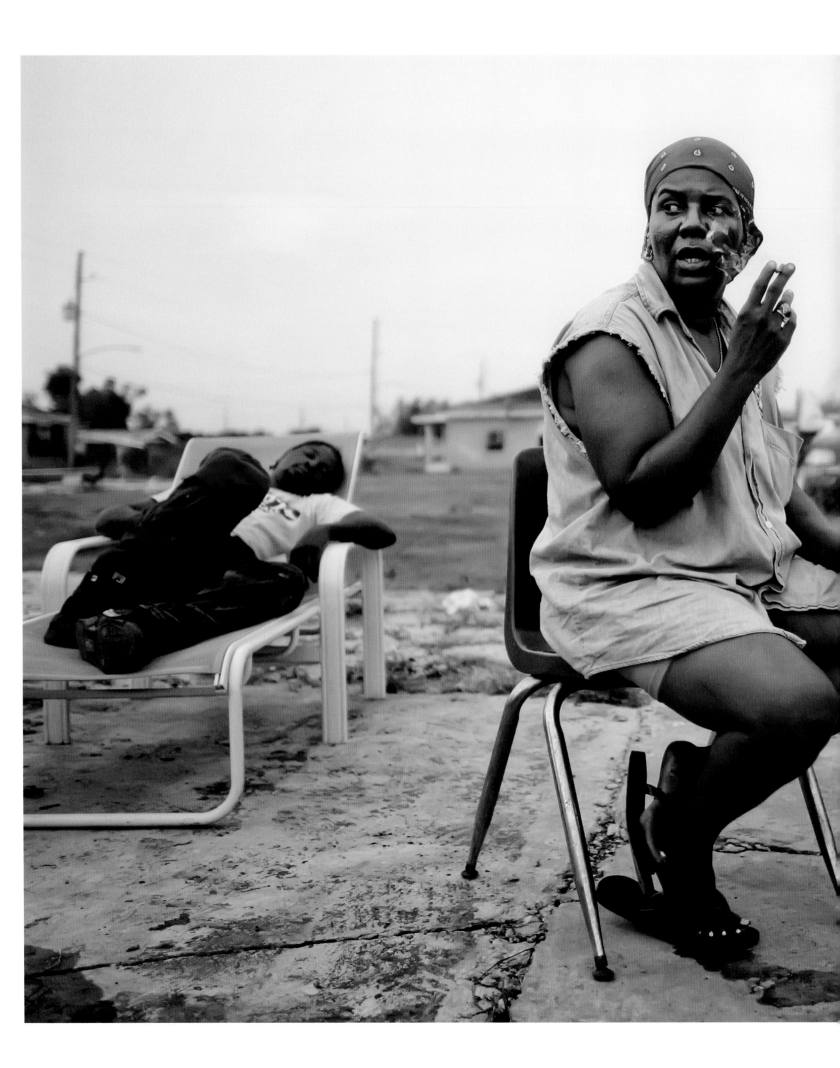

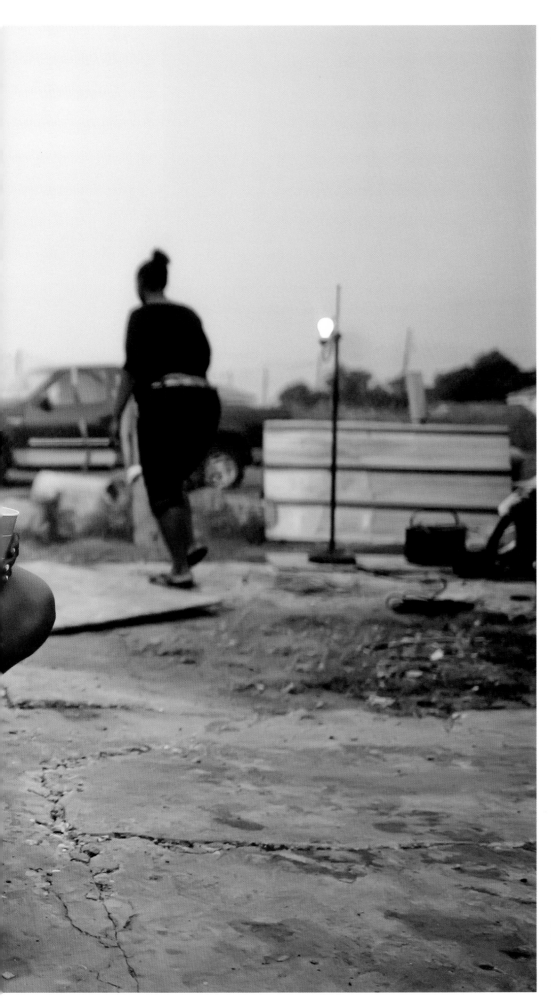

"The city isn't just my birthplace, it's my identity. I squat here furiously, as if someone else will become the person in New Orleans if I go away for more than a few days. I never evacuate during hurricanes."

—PATTY FRIEDMANN
"Home Is Still New Orleans"

Janice Miller smokes outside the old motor home where she was living with three other people in the Lower Ninth Ward, June 10, 2007, New Orleans. Most of the people living in the motor home said they could not afford rent in the city because prices increased following Hurricane Katrina in August 2005.

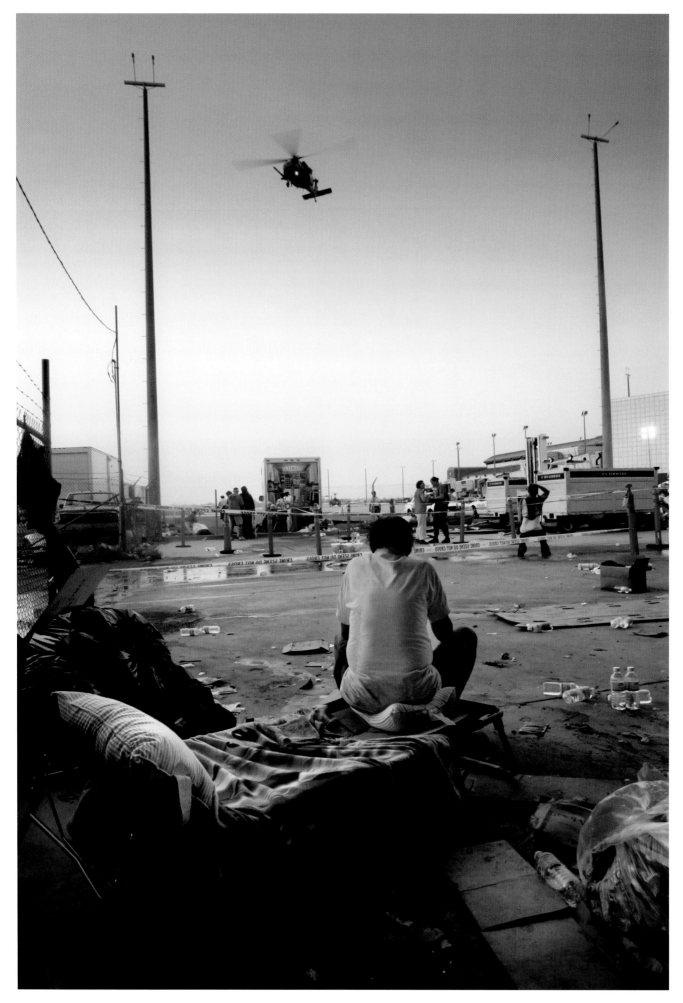

A stranded victim of Hurricane Katrina waits to be evacuated as an Army helicopter takes off from Louis Armstrong New Orleans International Airport, September 3, 2005, New Orleans. The airport served as a triage and evacuation point for victims of Hurricane Katrina.

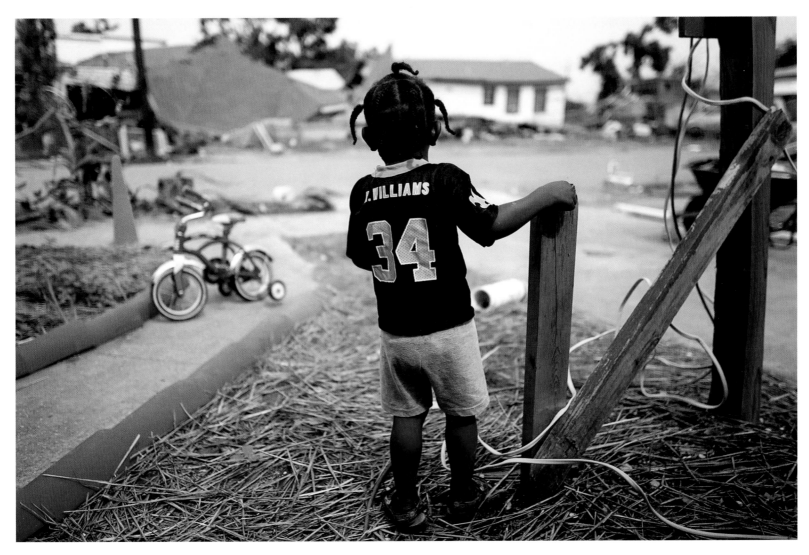

Shanika Reaux's son stands in the front yard of their residence in the Lower Ninth Ward, May 10, 2006, New Orleans.

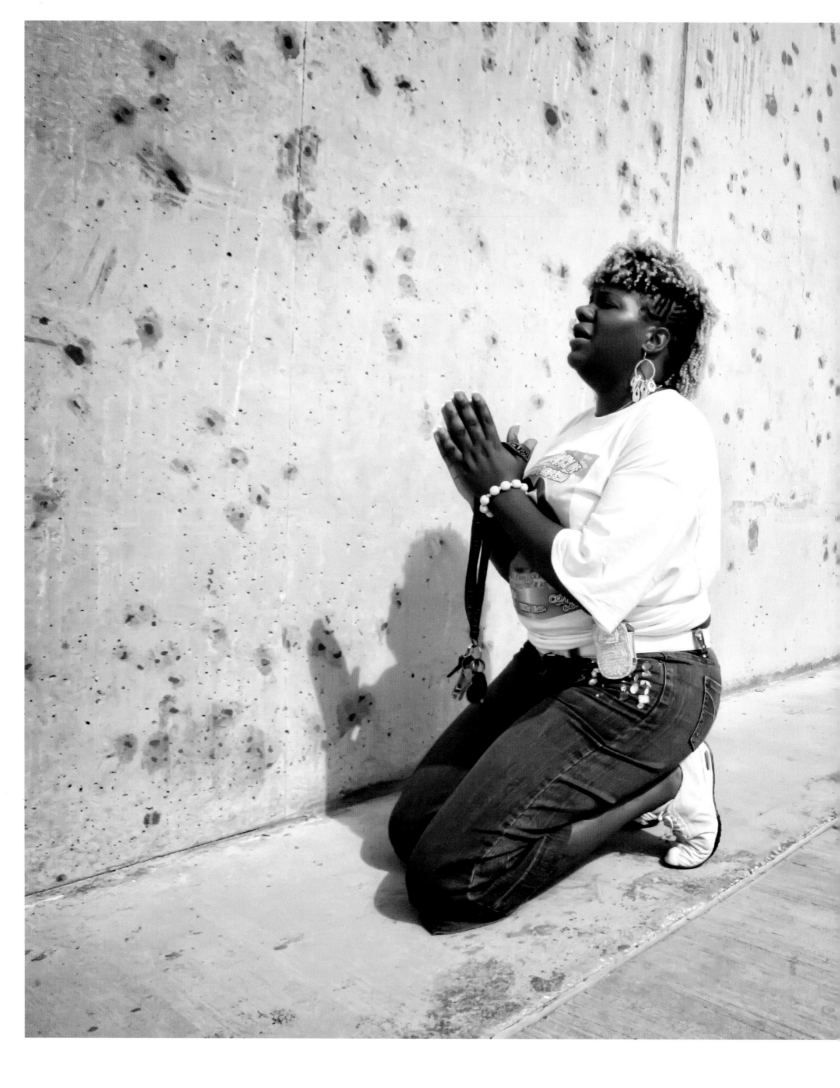

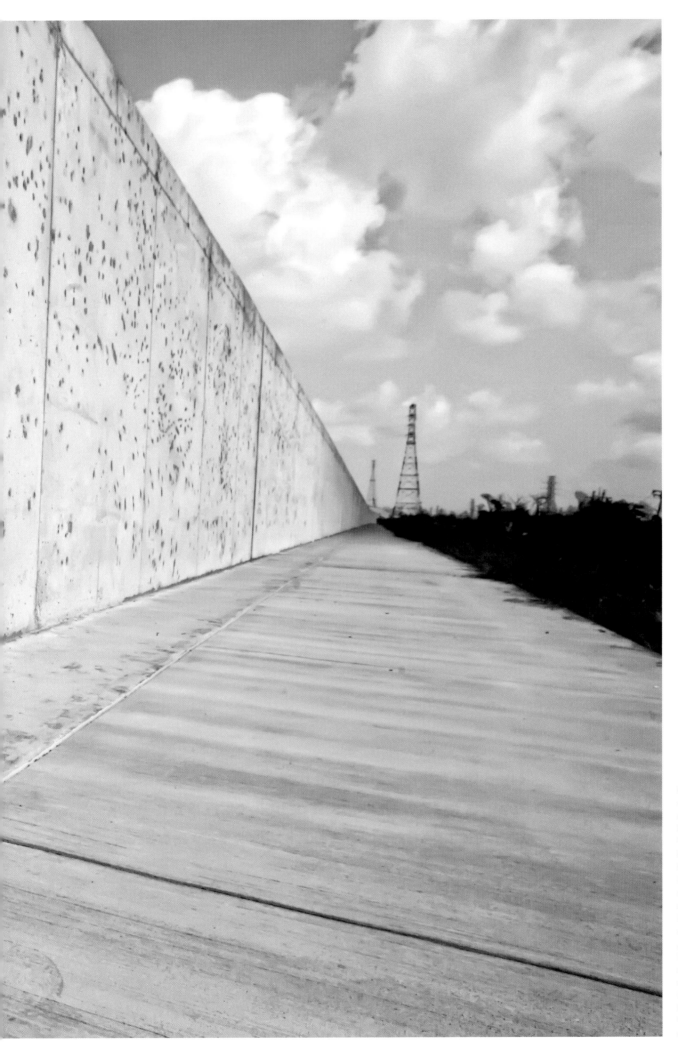

Oblique Weaver, who lost four family members, kneels in the Lower Ninth Ward at the repaired levee wall that was breached during Hurricane Katrina's aftermath while attending the Great Flood memorial ceremony and march, August 29, 2006, New Orleans. On the one-year anniversary of Hurricane Katrina, residents of the Gulf Coast remembered the victims and survivors of the storm.

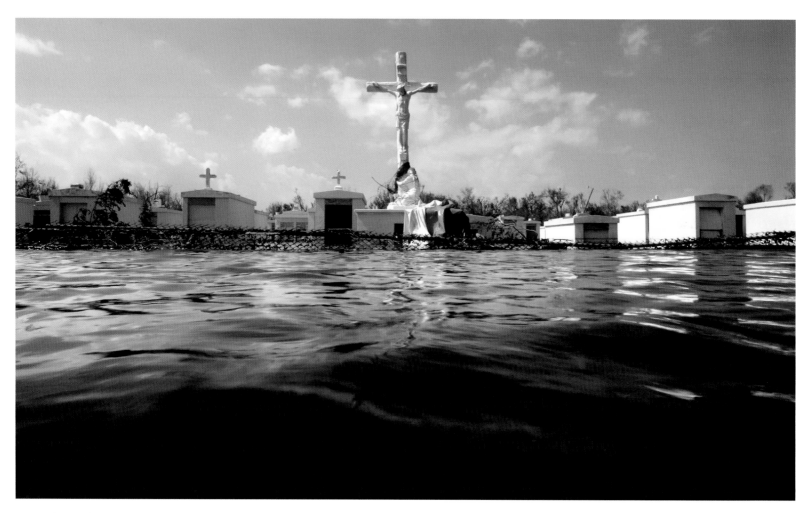

Saint Patrick Cemetery, September 11, 2005, Port Sulphur, Louisiana.

"I had the fleeting thought that everyone, dead or alive, returns to New Orleans. If people can't come back in their lifetime they come back when they are dead."

—ANDREI CODRESCU
New Orleans Stories

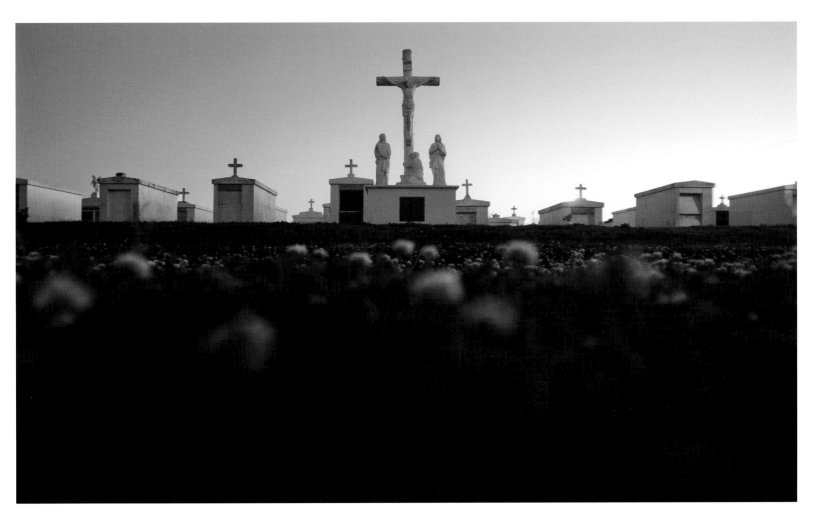

Saint Patrick Cemetery, March 20, 2008, Port Sulphur, Louisiana.

"A proper enough American city, and yet within the next few hours the tourist is apt to see more nuns and naked women than he ever saw before."

—WALKER PERCY
"New Orleans Mon Amour"

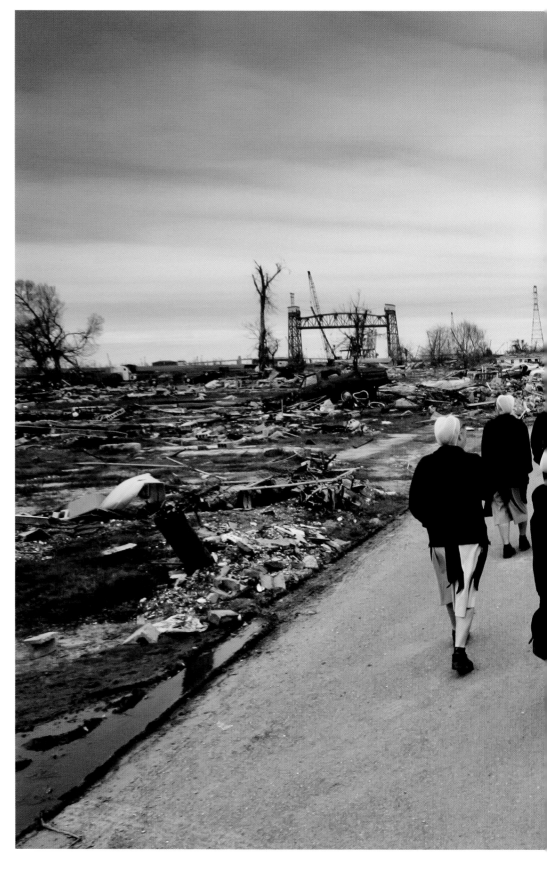

A group of Amish student volunteers tour the devastated Lower Ninth Ward, February 24, 2006, New Orleans.

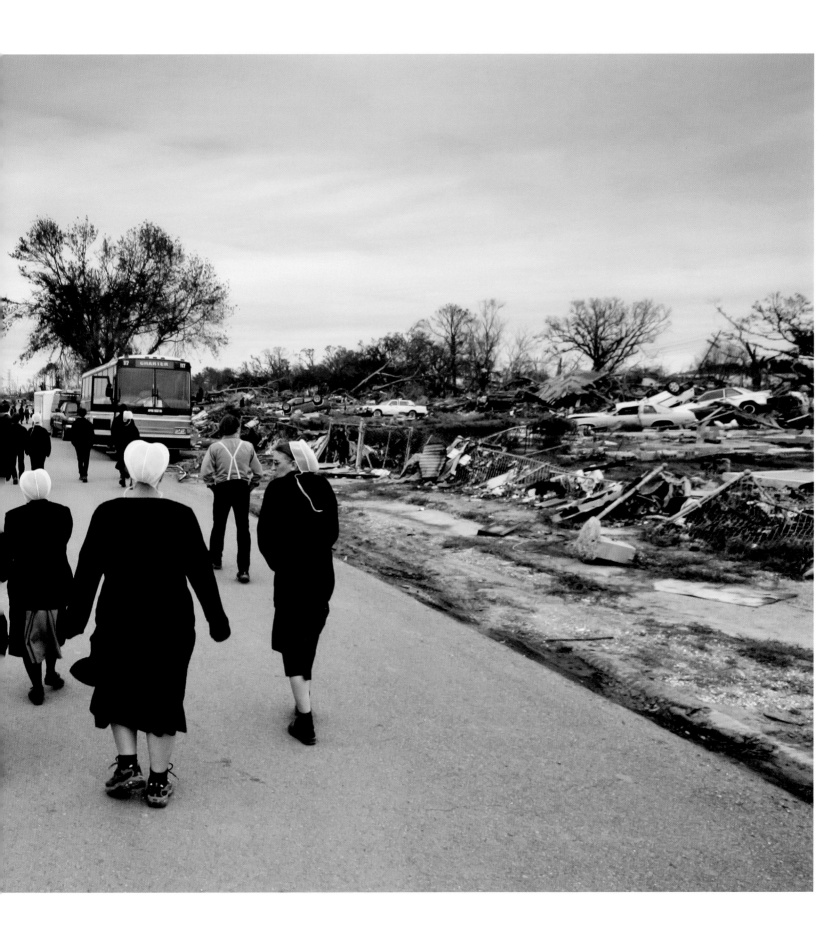

"After all, high station in life is earned by the gallantry with which appalling experiences are survived with grace."

—TENNESSEE WILLIAMS
Memoirs

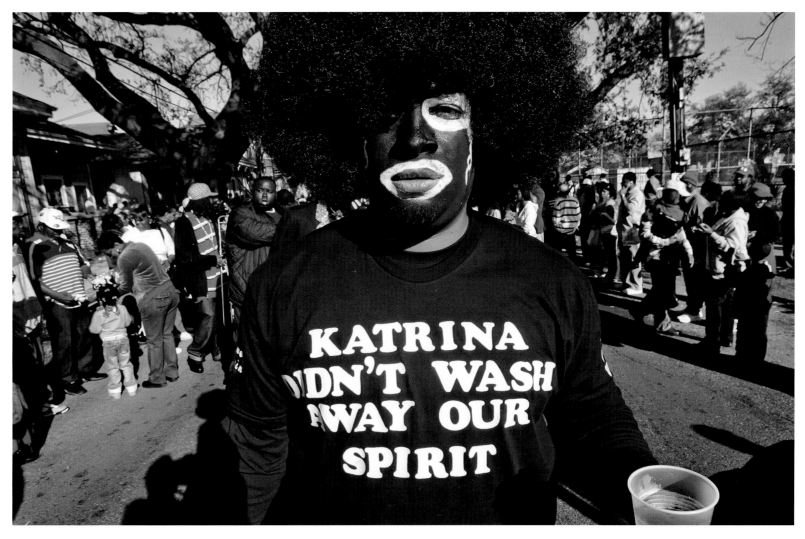

A member of the Zulu Social Aid and Pleasure Club walks in the Zulu Parade during Fat Tuesday Mardi Gras festivities, February 28, 2006, New Orleans.

"An hour isn't just an hour
but a piece of eternity
dropped in your hands."

—TENNESSEE WILLIAMS
A Streetcar Named Desire

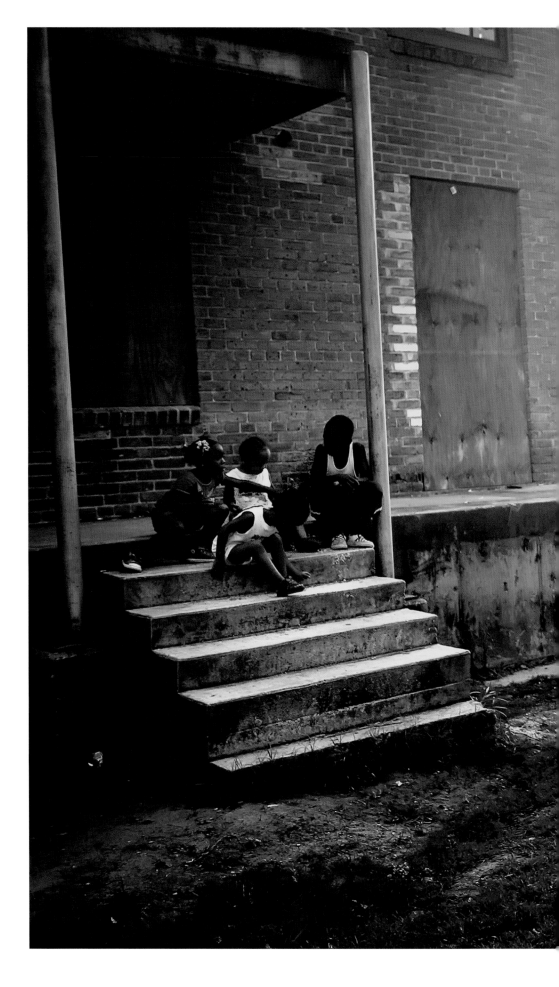

Children gather in the B.W. Cooper housing
project, June 10, 2007, New Orleans.

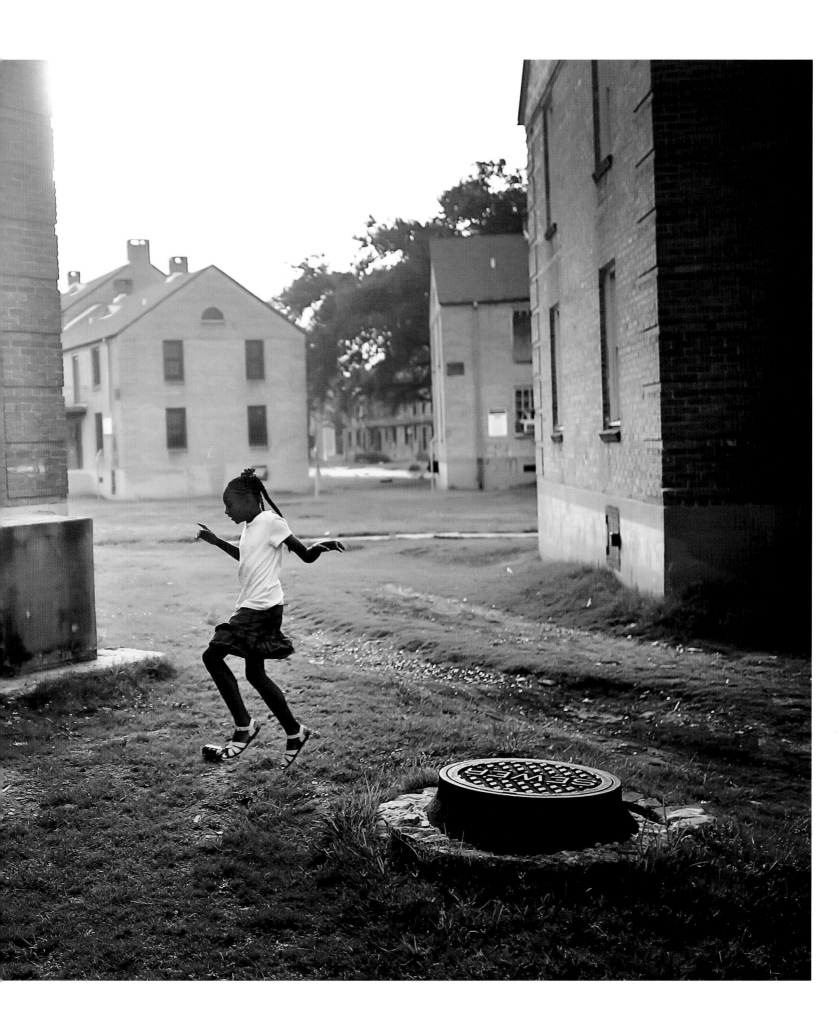

"New Orleans is about fantasy. It's about desire and the awareness of mortality. It's a collection of stories, most of which will never be written."

—ELIZABETH DEWBERRY
"Cabaret Stories"

A girl looks on as women dance after the Original Big 7 Social Aid and Pleasure Club held a traditional second line parade in the Seventh Ward, May 14, 2006, New Orleans. The tradition sprang from when African Americans formed brass marching bands and fraternal groups to perform elaborate "jazz funerals" for their associates.

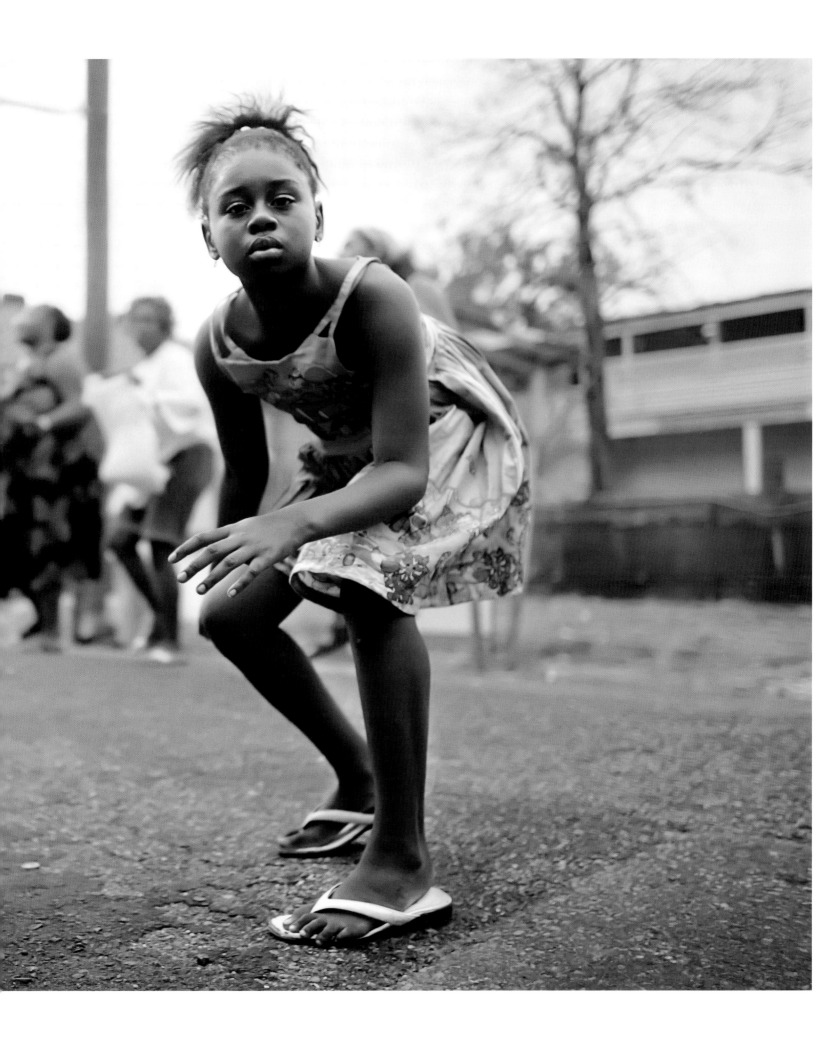

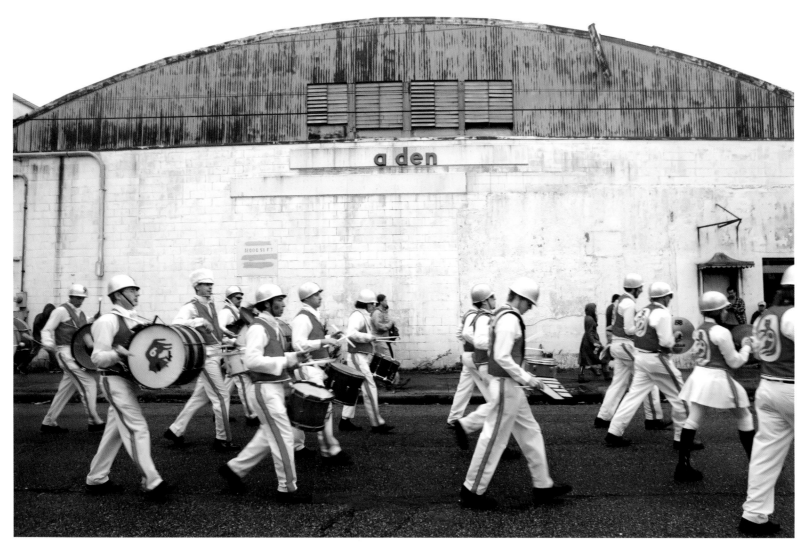

Members of the Ninth Ward Marching Band march during an unofficial Mardi Gras parade, February 25, 2006, New Orleans. New Orleans was celebrating its first Mardi Gras since Hurricane Katrina.

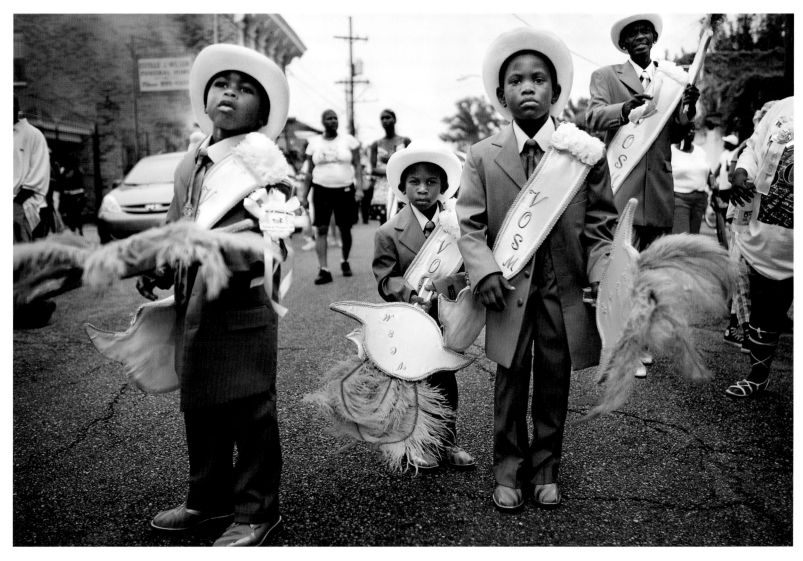

Boys participate in the Valley of the Silent Men Social Aid and Pleasure Club Second Line Parade,
August 26, 2007, New Orleans.

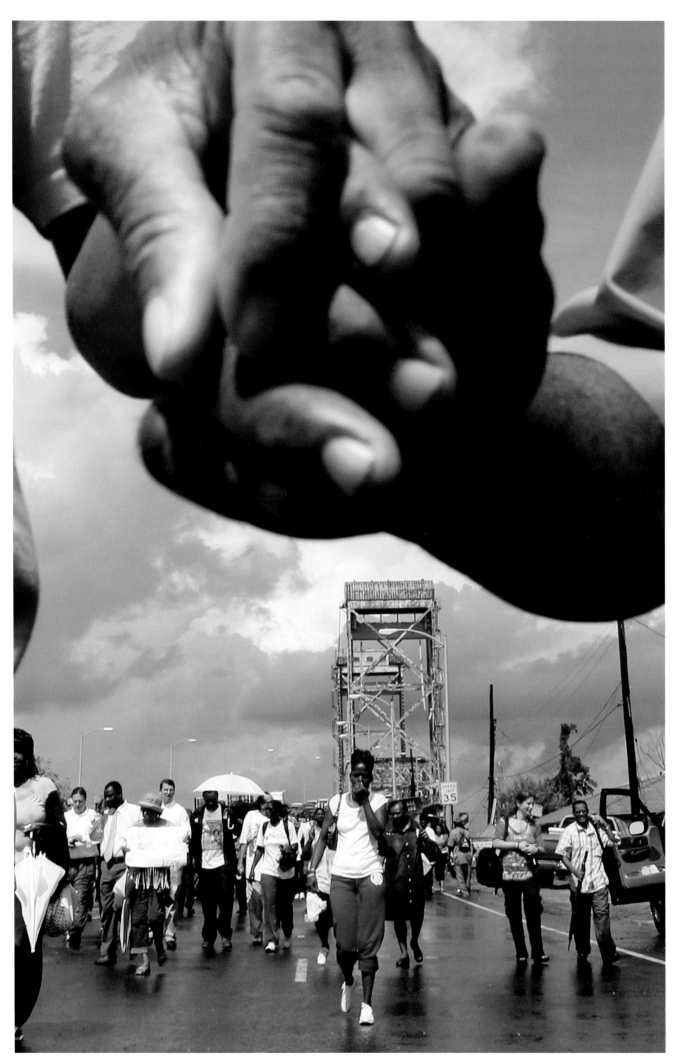

Protesters march down the bridge spanning the Industrial Canal into the Lower Ninth Ward, August 29, 2007, New Orleans.

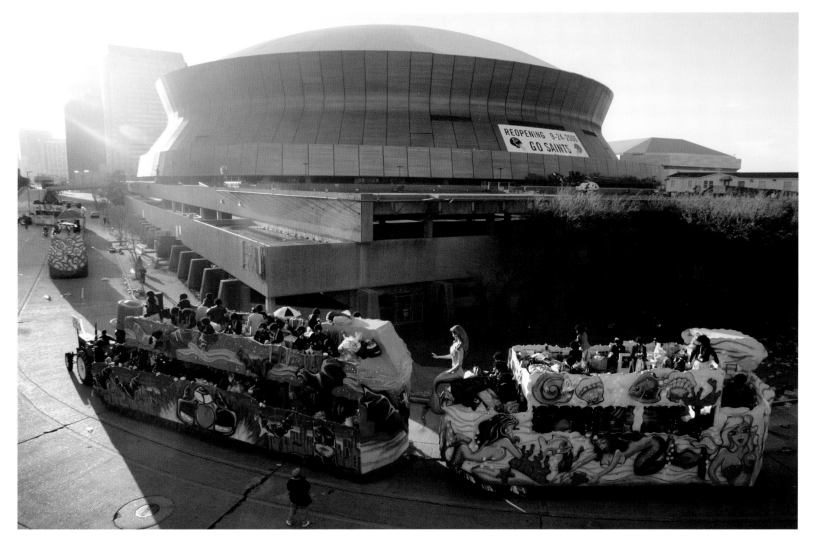

Floats pass the Superdome before the beginning of the Zulu Parade during Fat Tuesday Mardi Gras festivities, February 28, 2006, New Orleans. New Orleans was celebrating its first Mardi Gras since Hurricane Katrina.

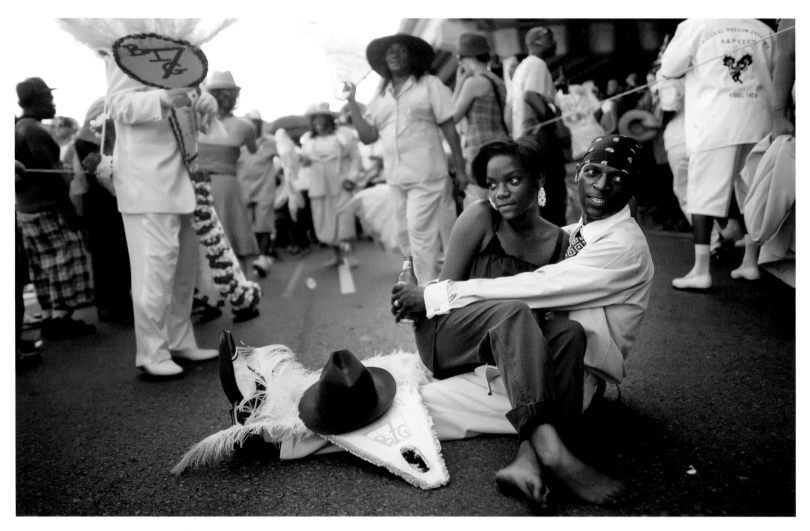

Members of the Original Big 7 Social Aid and Pleasure Club hold a traditional
second line parade in the Seventh Ward, May 10, 2009, New Orleans.

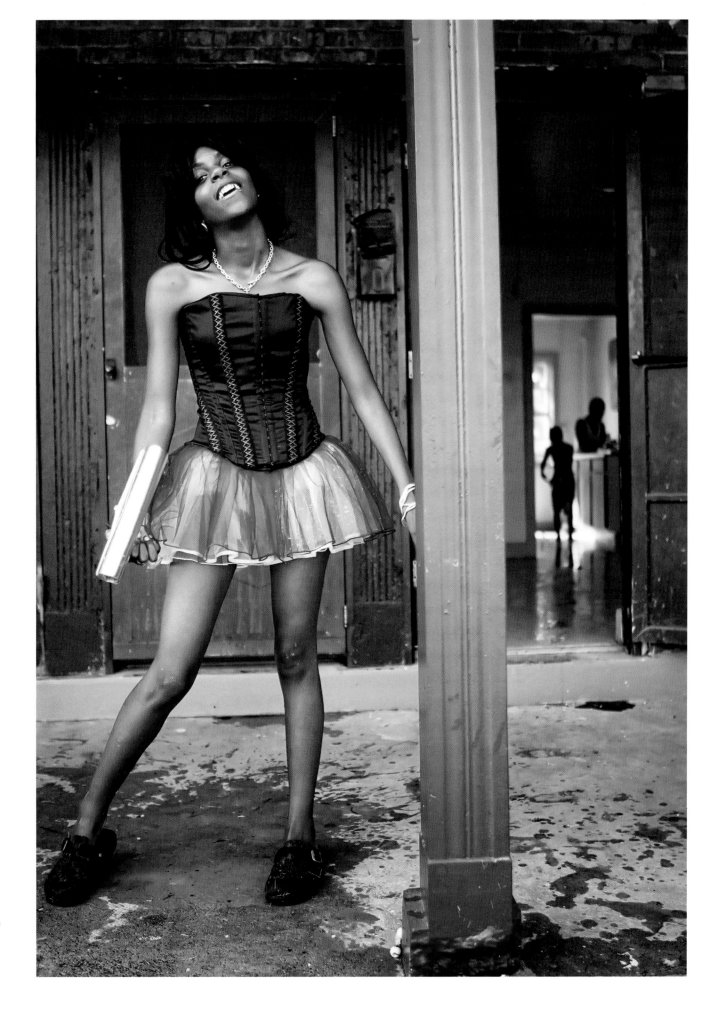

A resident looks on in the B.W. Cooper housing project, August 25, 2007, New Orleans.

75

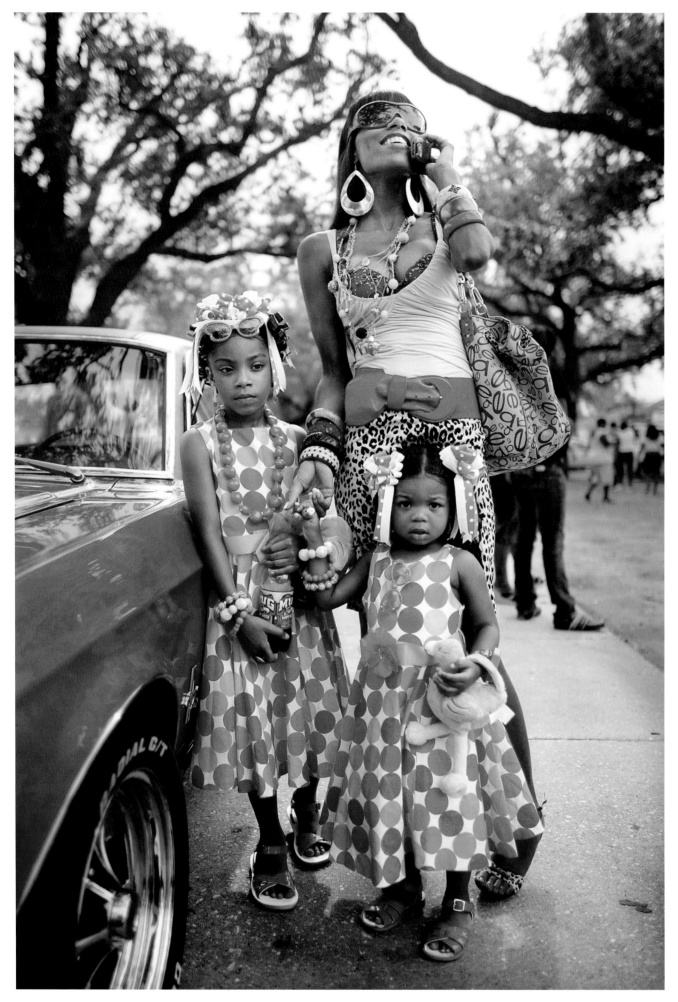

Angel Price talks on her cell phone with her daughters Brielle, eight, and Cache, two, as the Original Big 7 Social Aid and Pleasure Club holds a traditional second line parade in the Seventh Ward, May 14, 2006, New Orleans.

"New Orleanians don't go out of the house without fixing up as best they can, and that usually means in a way to catch other people's attention."

—LEAH CHASE
 "Our Slow Curve"

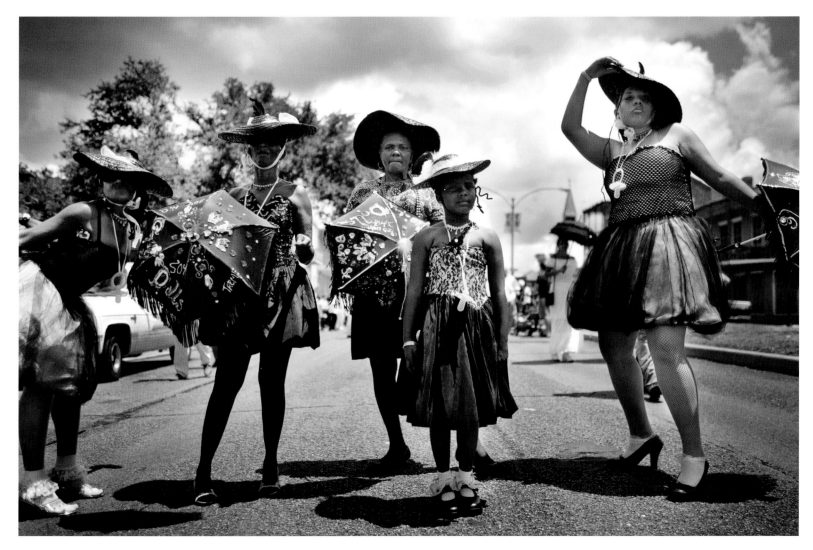

Paraders pose while marching in the Satchmo Summerfest Second Line Parade, August 6, 2006, New Orleans.

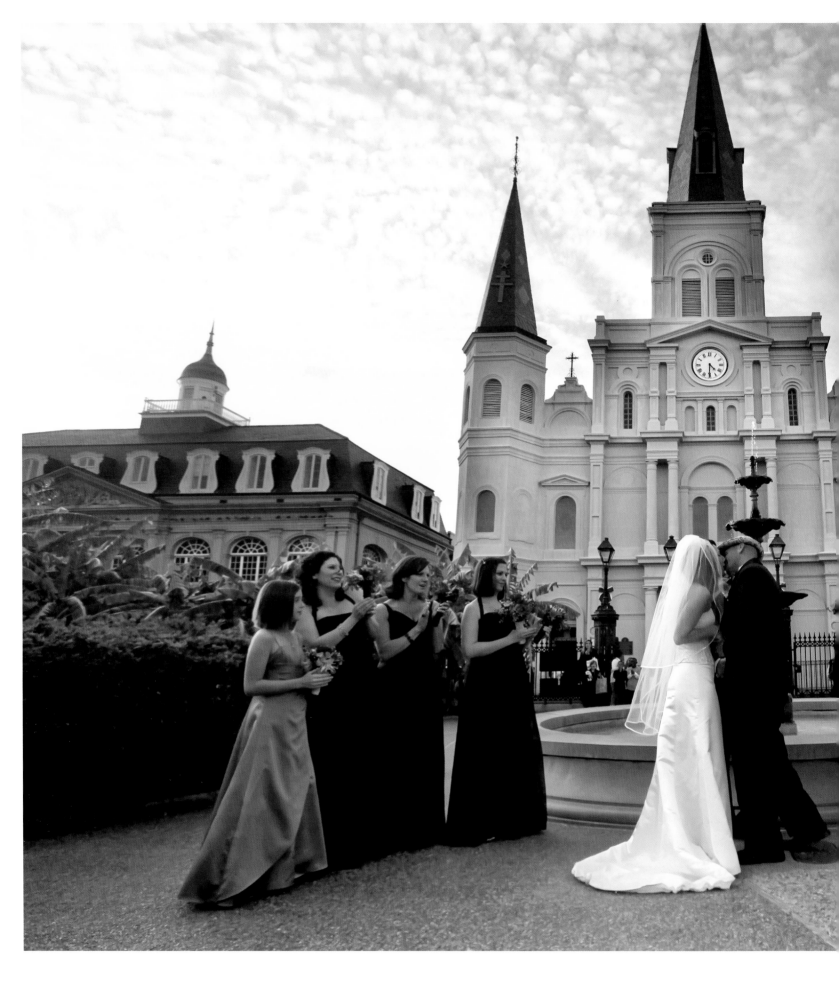

Chris and Phylis Keller are married in front of
Saint Louis Cathedral in the French Quarter,
November 28, 2009, New Orleans.

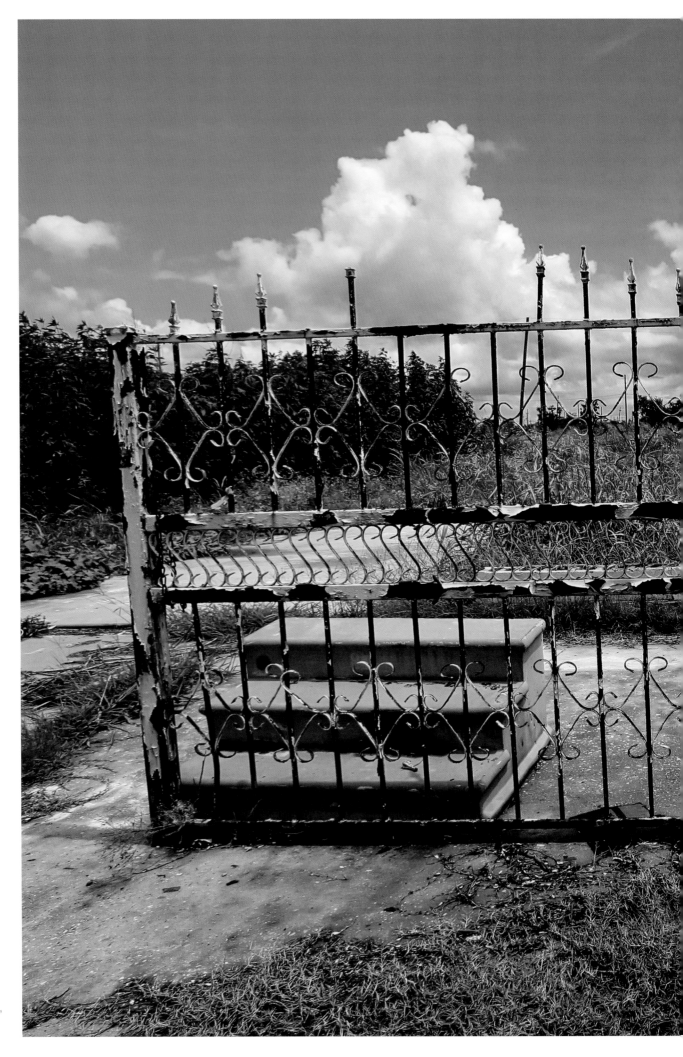

Stairs and a gate
surround the slab of
a former home in
the Lower Ninth Ward,
August 17, 2007,
New Orleans.

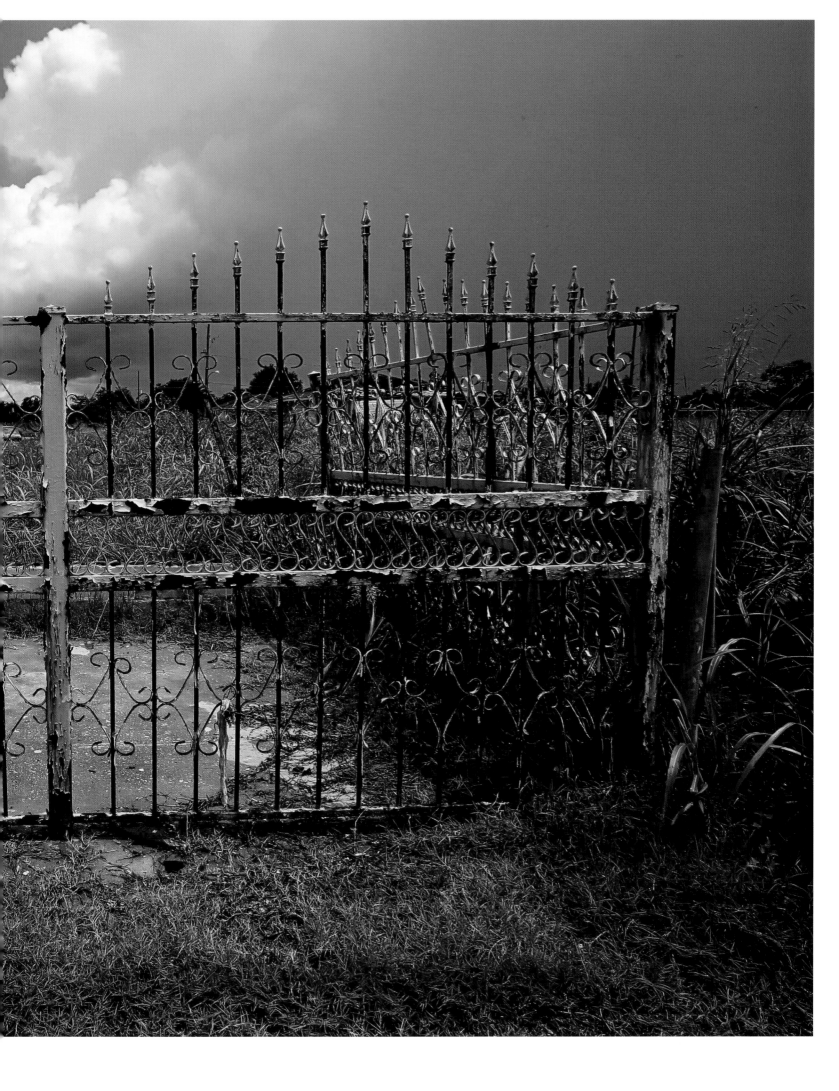

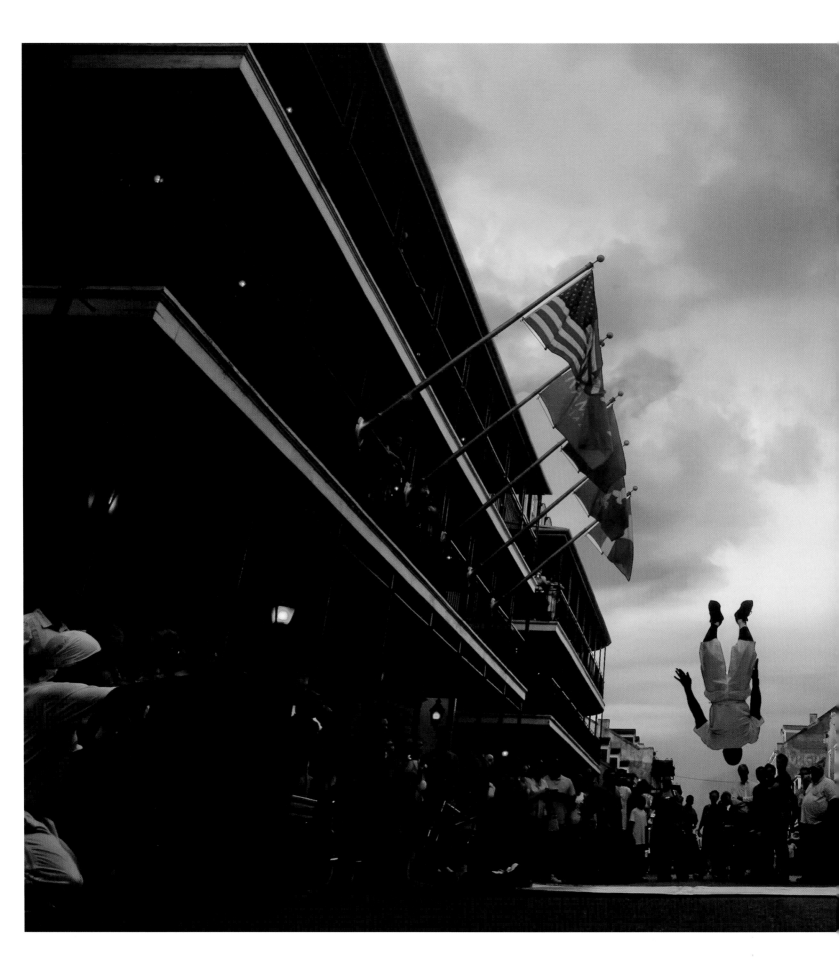

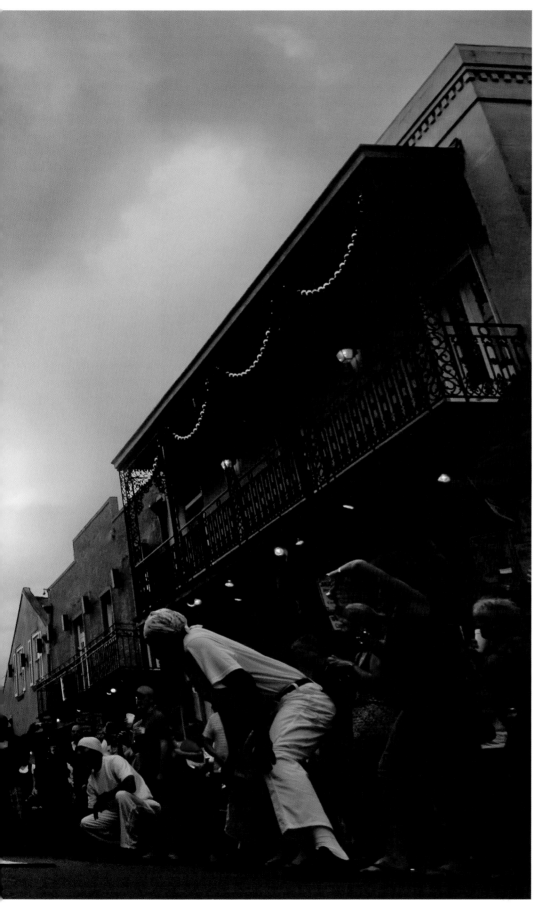

"Way down yonder in New Orleans / In the land of dreamy scenes / There's a garden of Eden / You know what I mean."

—HENRY CREAMER
"Way Down Yonder in New Orleans"

A street performer flips for the crowd on Bourbon Street in the French Quarter, May 15, 2009, New Orleans.

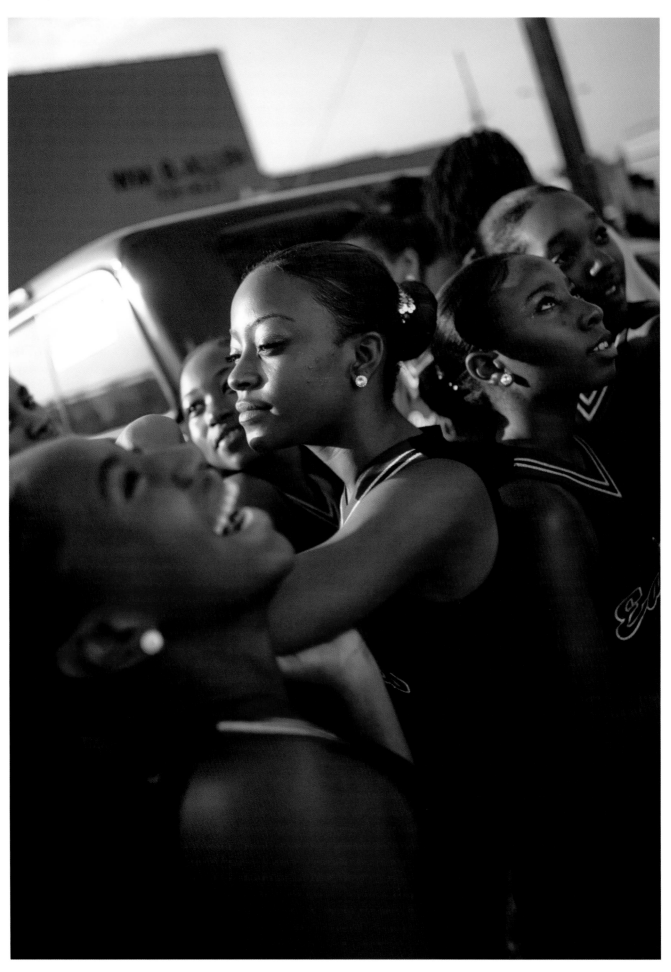

Girls from the McDonogh Senior High School Eaglettes clown around while
waiting to perform in a Shriners Parade, August 23, 2006, New Orleans.

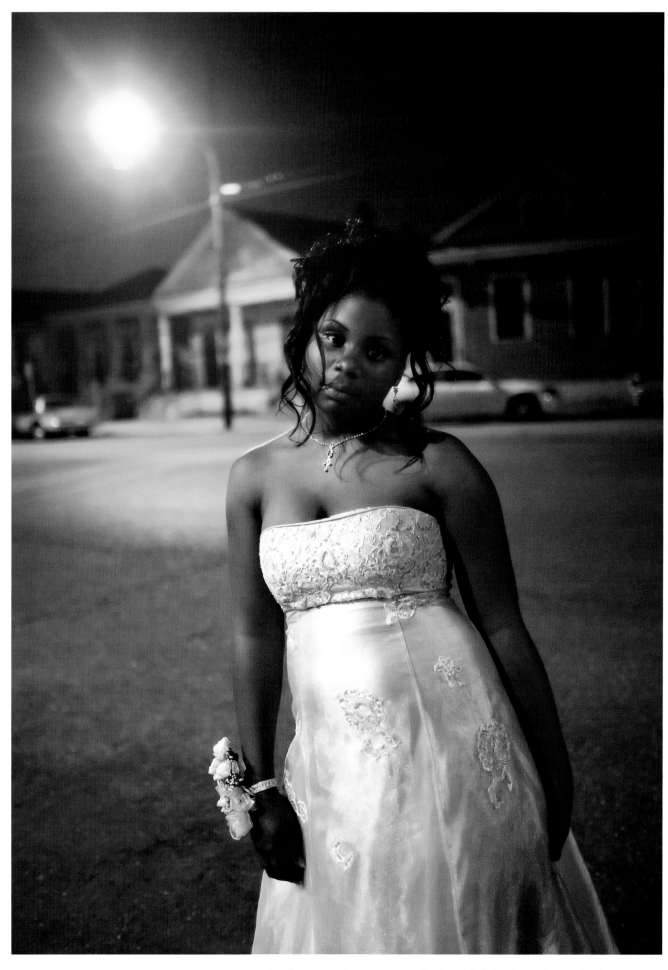

Kirrione Jones from McDonogh Senior High School stands outside after attending her prom, June 1, 2007, New Orleans. It was the inner-city school's first prom since Hurricane Katrina.

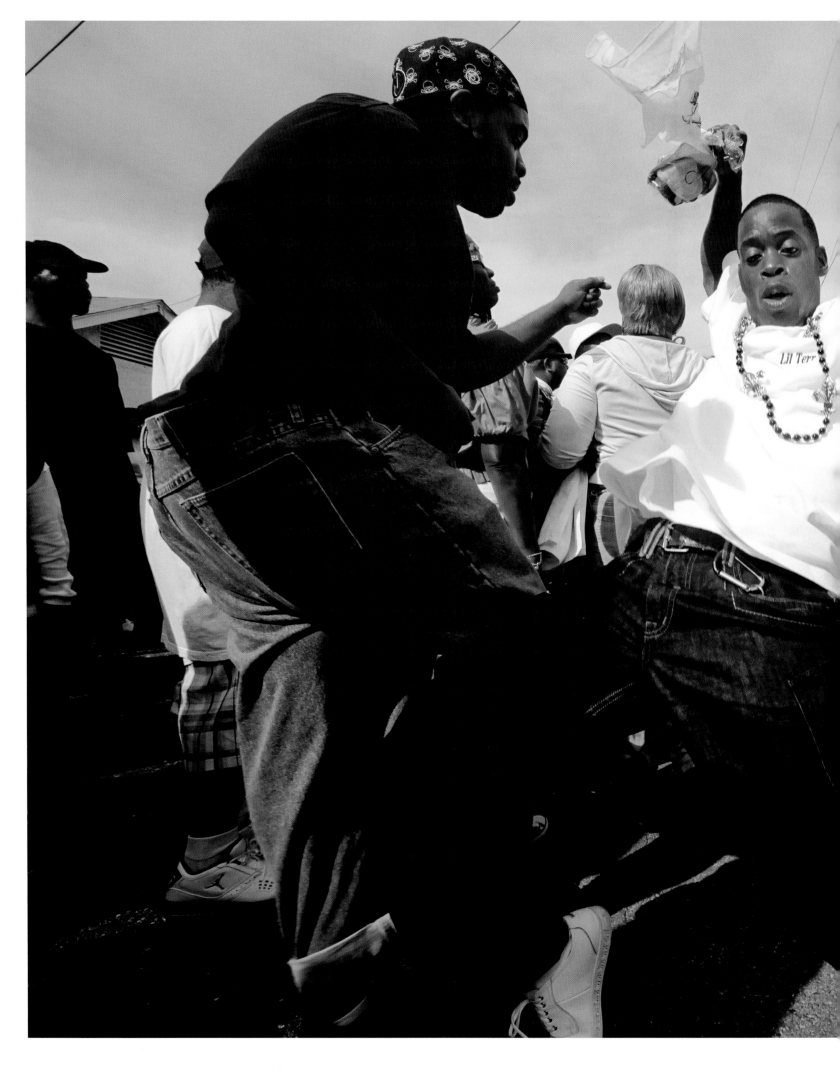

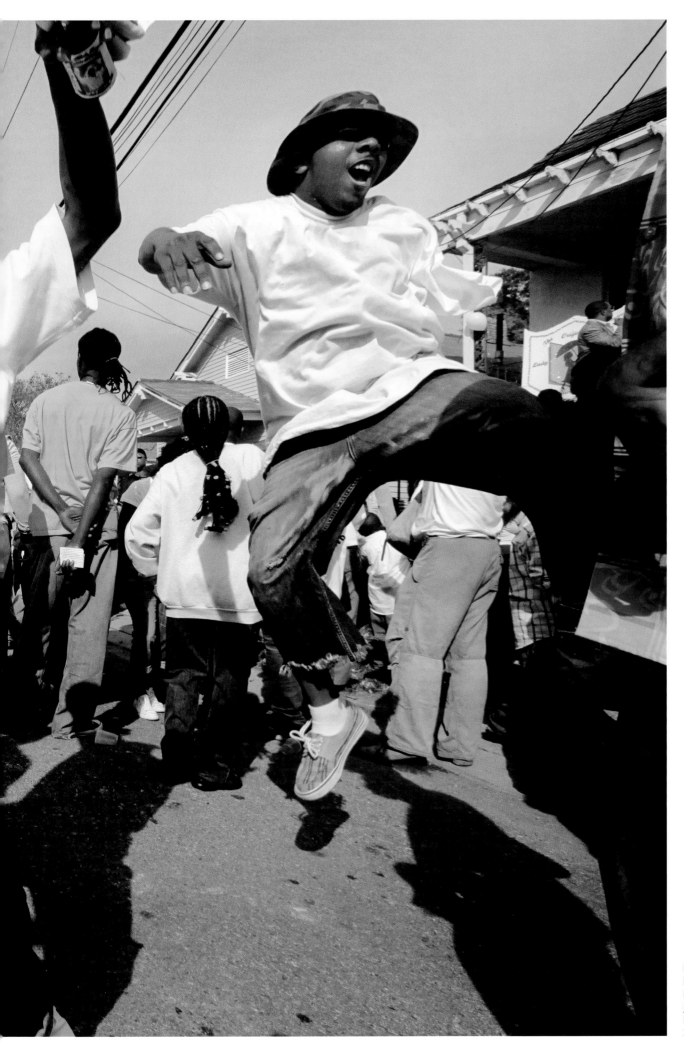

Revelers participate in the Original Ladies, Kids and Men Buck-jumpers Second Line Parade, November 29, 2009, New Orleans.

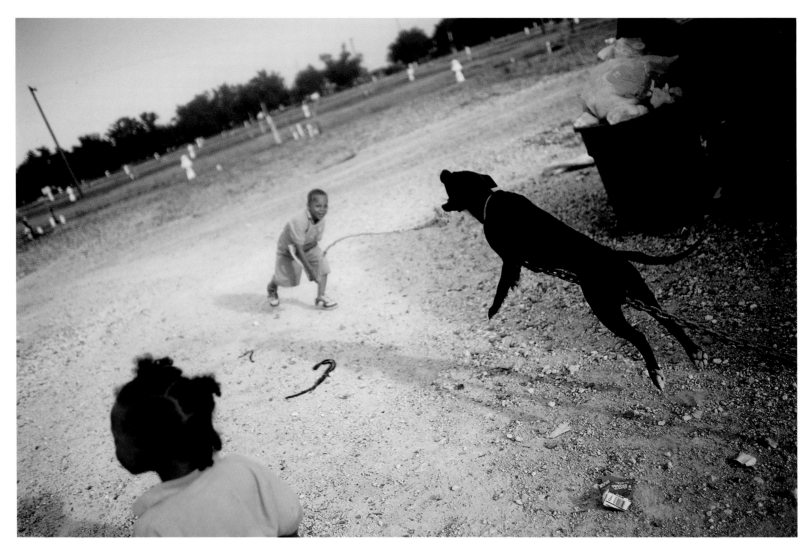

Herschel Barthelemy plays with a family dog outside their FEMA trailer, May 11, 2009, Port Sulphur, Louisiana. Seven children from the family lived in the trailer after their home was destroyed by Hurricane Katrina. Approximately 2,000 families in the New Orleans metropolitan area still lived in FEMA trailers nearly four years after Hurricane Katrina. Eighty percent of those still in trailers were homeowners who were not able to return to their storm-damaged houses.

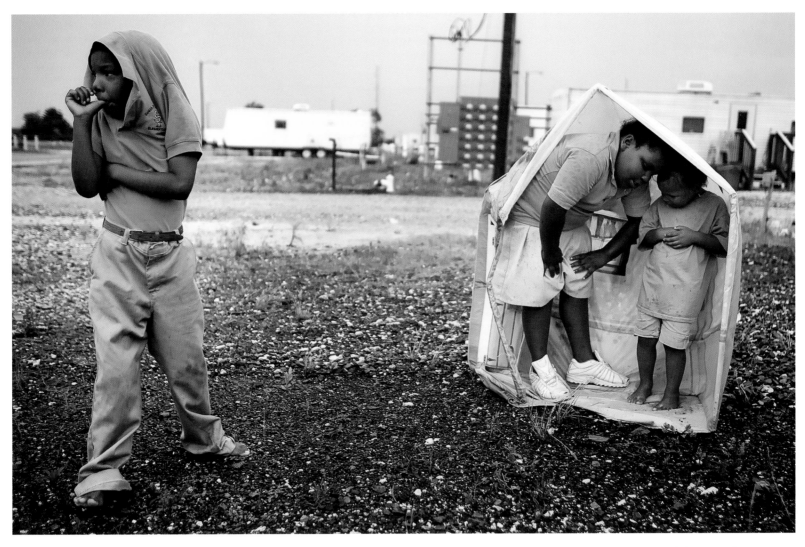

Children play in the rain in the FEMA Diamond travel trailer park, May 22, 2008, Port Sulphur, Louisiana.

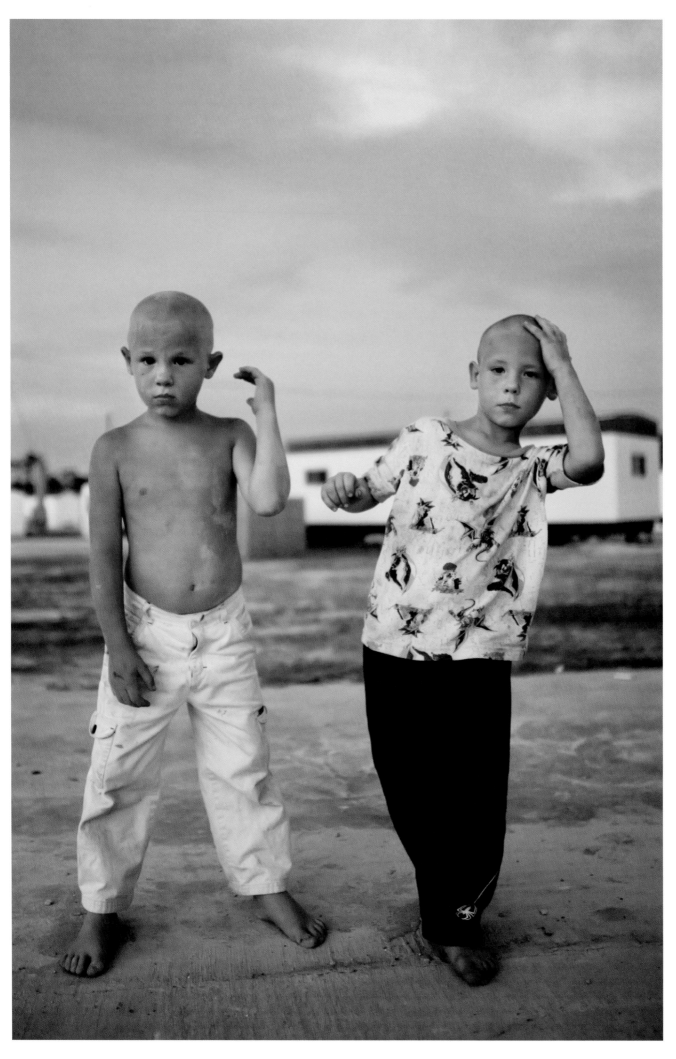

Brandon Caughhorn, seven, and Nathan Caughhorn, five, stand inside the FEMA trailer park where they live after their homes were destroyed by Hurricane Katrina, May 27, 2006, Waveland, Mississippi.

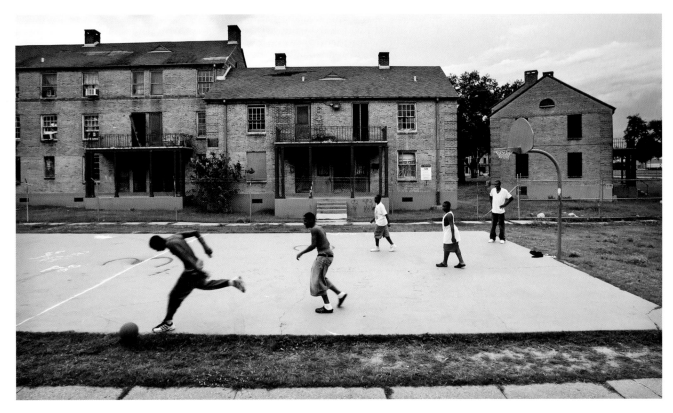

B.W. Cooper residents play basketball in front of shuttered apartments, June 9, 2007, New Orleans.

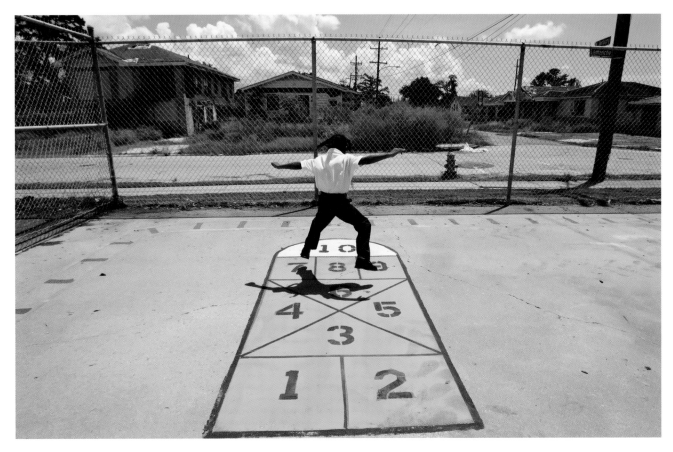

A kindergartner plays hopscotch on his first day of school at Dr. Martin Luther King Jr. Charter School for Science and Technology in the Lower Ninth Ward, August 20, 2007, New Orleans. The school, closed since Katrina swept through in 2005 leaving it under 14 feet of water, finally reopened, August 13, 2007, to older students. This was the first day for kindergarten and pre–K.

"That old Mississippi River has never had one ounce of racial prejudice. . . . When it comes bursting over those levees, it doesn't stop and ask where the colored section is."

—AARON HENRY
The Fire Ever Burning

Isabella Lander and Arabella Christiansen climb on the 17th Street Canal levee, May 29, 2008, Metairie, Louisiana.

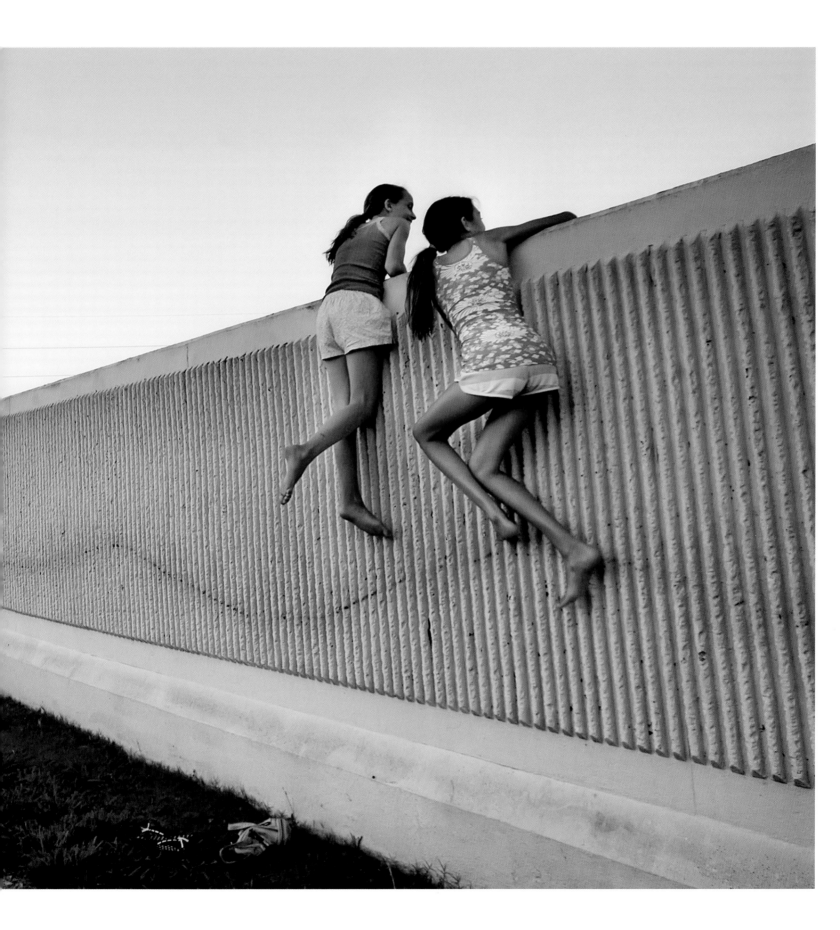

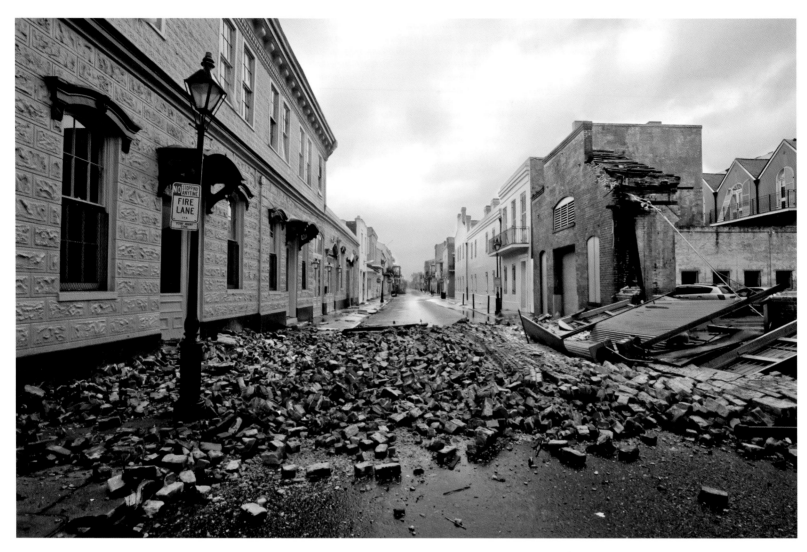

A toppled brick wall on Burgundy Street in the French Quarter after
Hurricane Katrina, August 29, 2005, New Orleans.

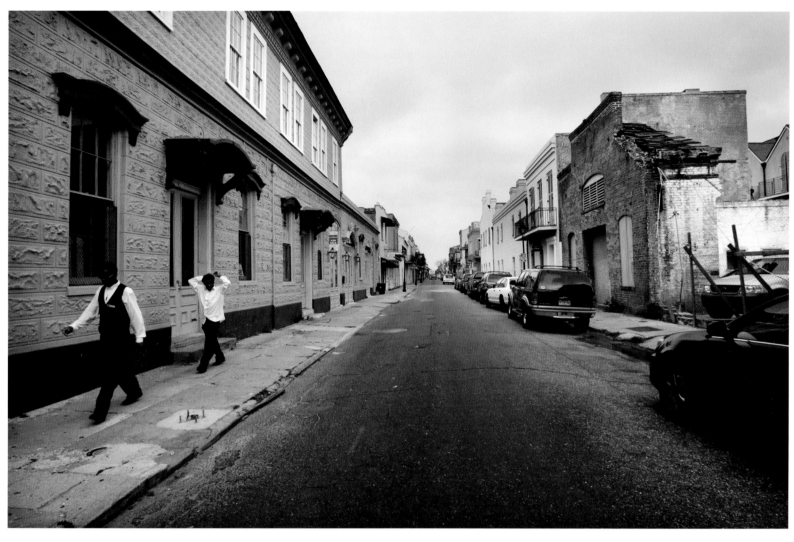

Boys walk along Burgundy Street, March 17, 2008, New Orleans.

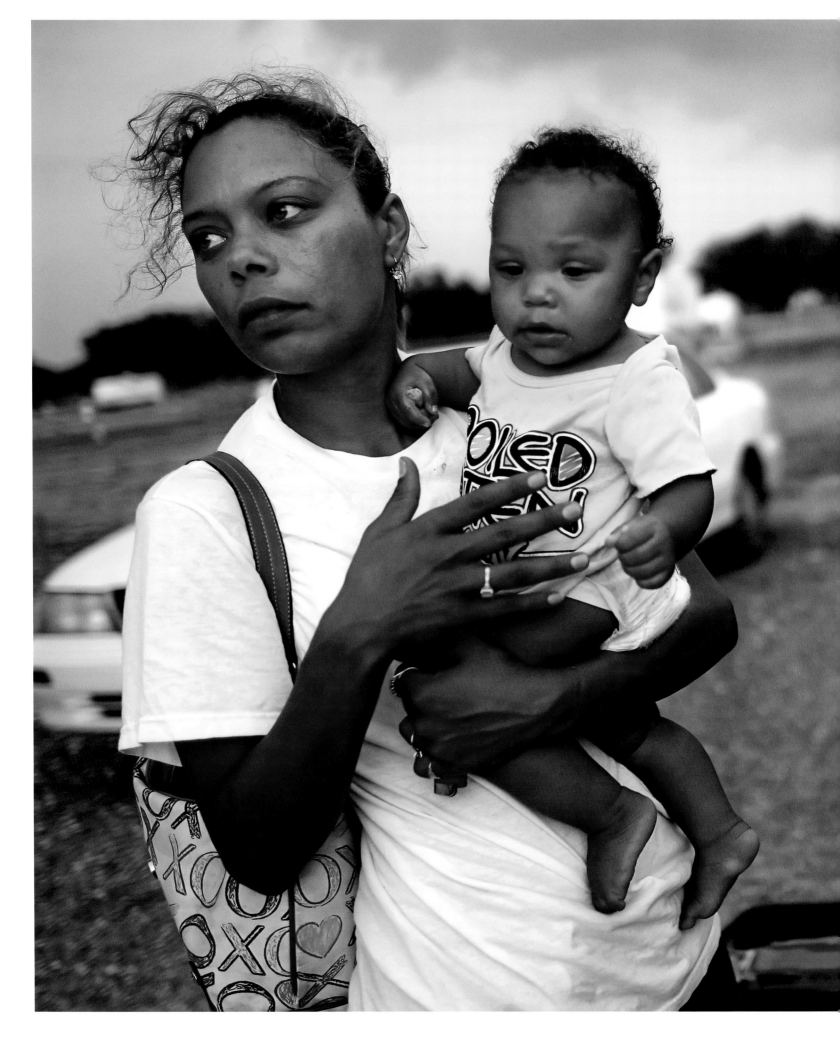

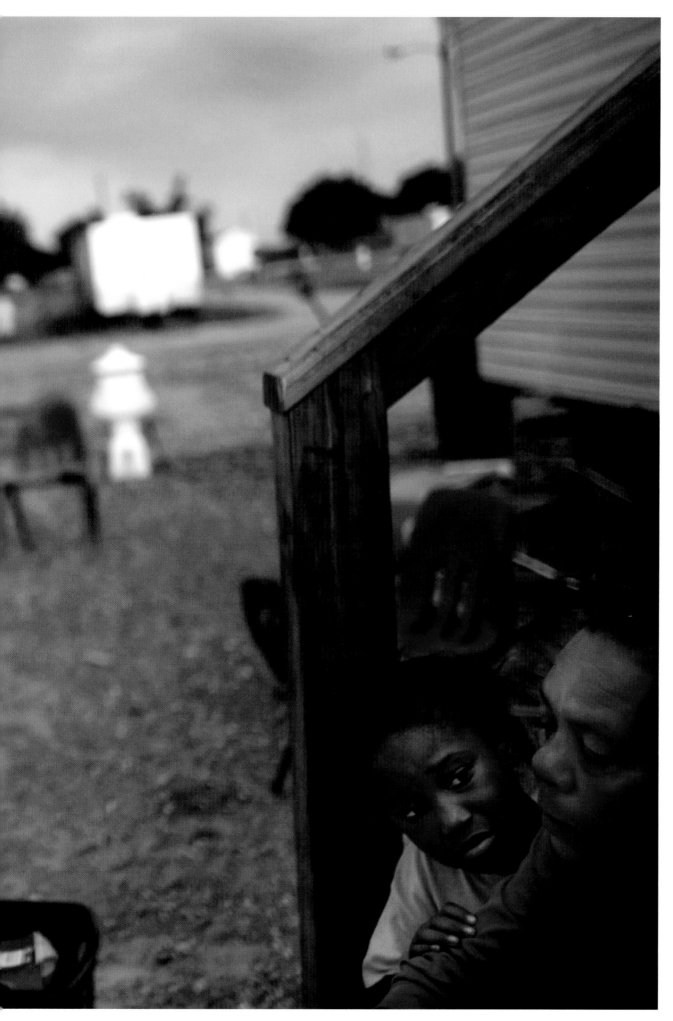

Shelly Phillips holds niece Kimmore Barthelemy in the FEMA Diamond travel trailer park, May 26, 2008, Port Sulphur, Louisiana. Phillips lost her home and job in Hurricane Katrina and was raising four children.

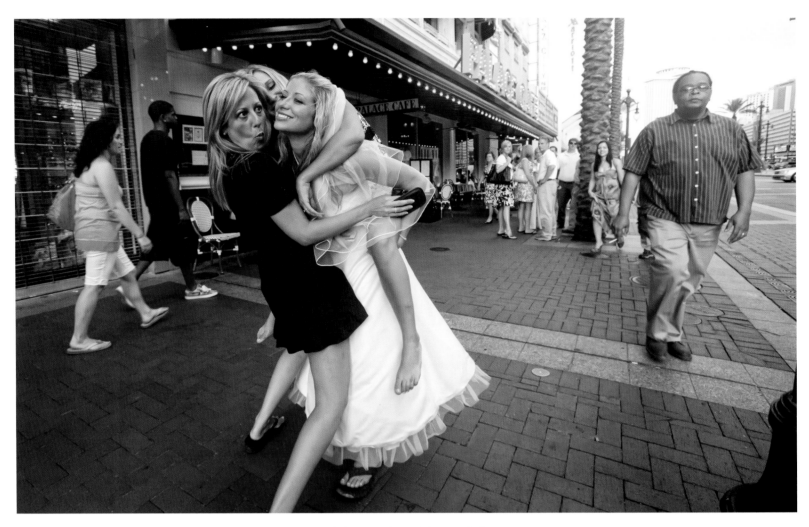

Bride Samantha Hebert celebrates with friends in the French Quarter after getting married, May 9, 2009, New Orleans.

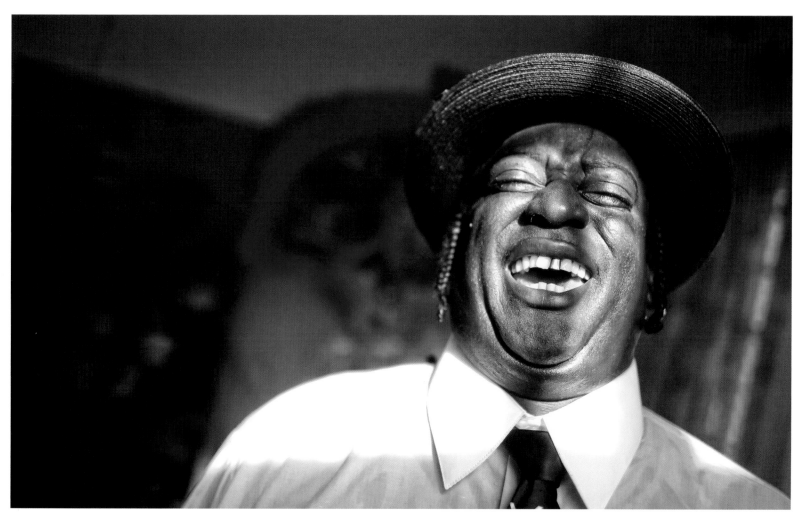

Edward Buckner enjoying himself at the Original Big 7 Social Aid and Pleasure Club Second Line Parade in the Seventh Ward, May 10, 2009, New Orleans.

Lauren and Jana,
tourists from Utah,
ride a streetcar, May
15, 2009, New Orleans.

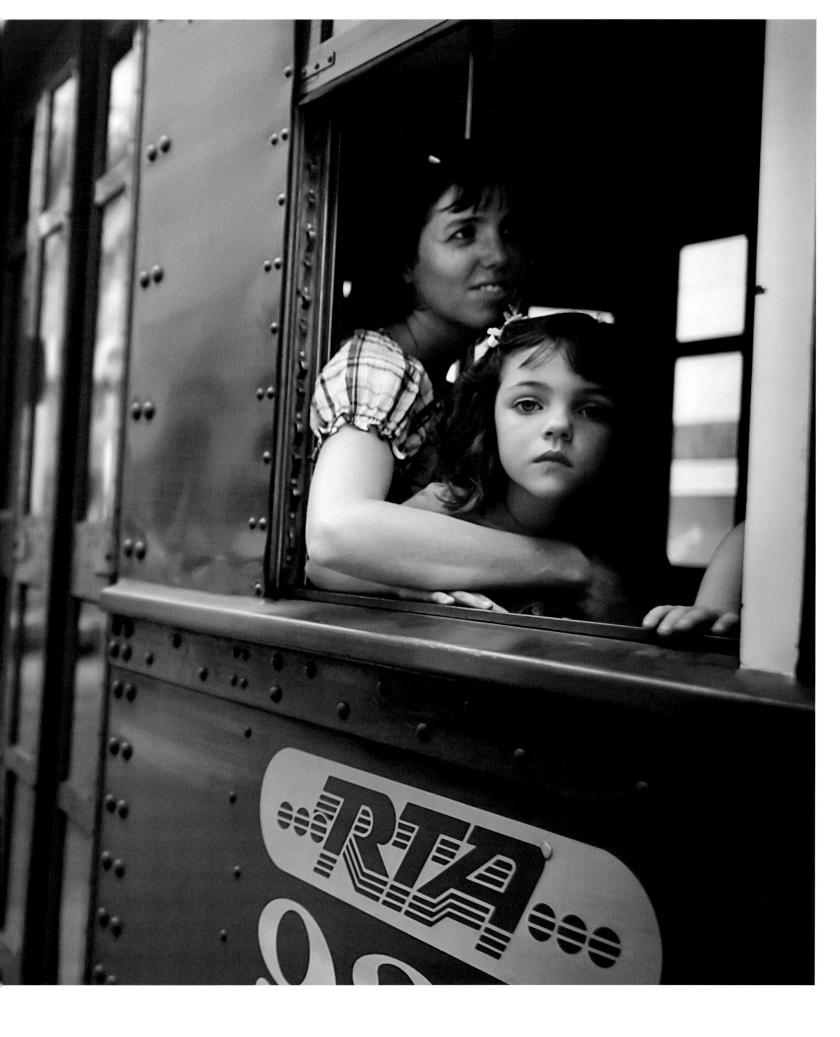

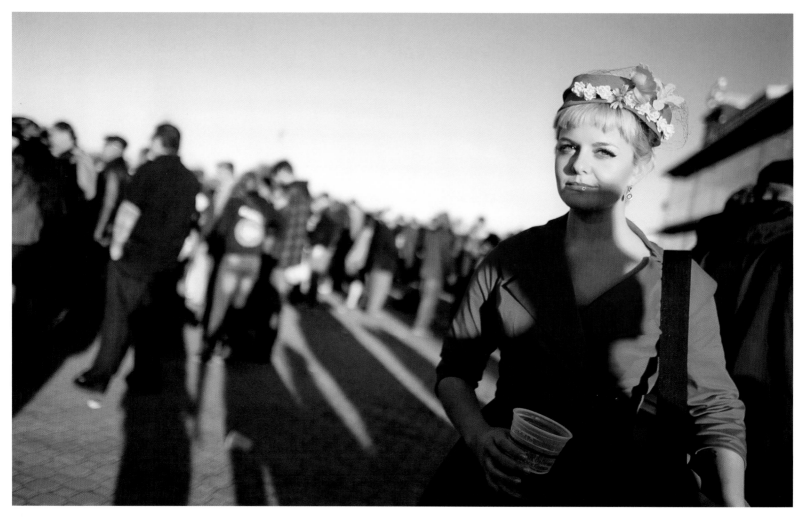

Camilla Brewer attends the Thanksgiving Day horse races at the Fair Grounds Race Course, November 26, 2009, New Orleans. Each year people don their Thanksgiving finest and watch the races in an old New Orleans tradition.

"Our greatest asset, our ability to forget our cares and enjoy life, is also our failing."

—ELLA BRENNAN
"The Secret Ingredient"

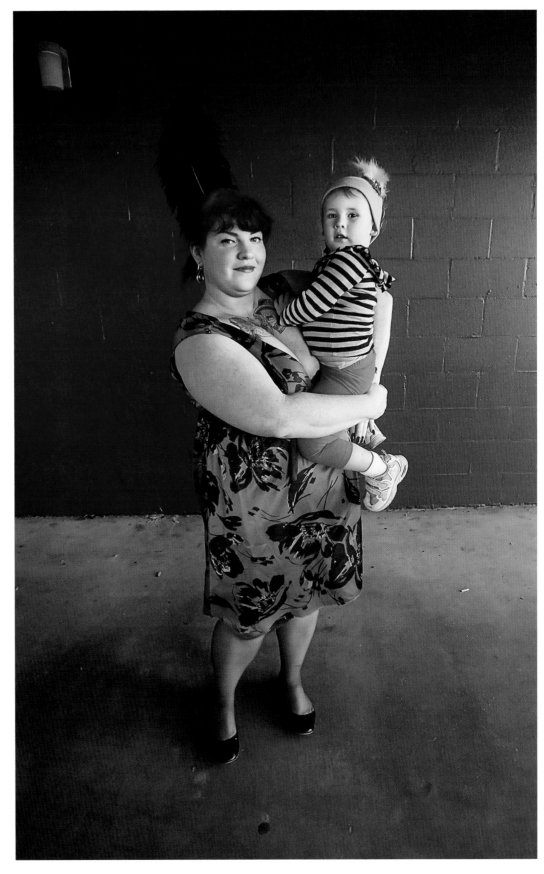

Jillian Bordelon holds Josie Bates while attending the Thanksgiving Day horse races at the Fair Grounds Race Course, November 26, 2009, New Orleans.

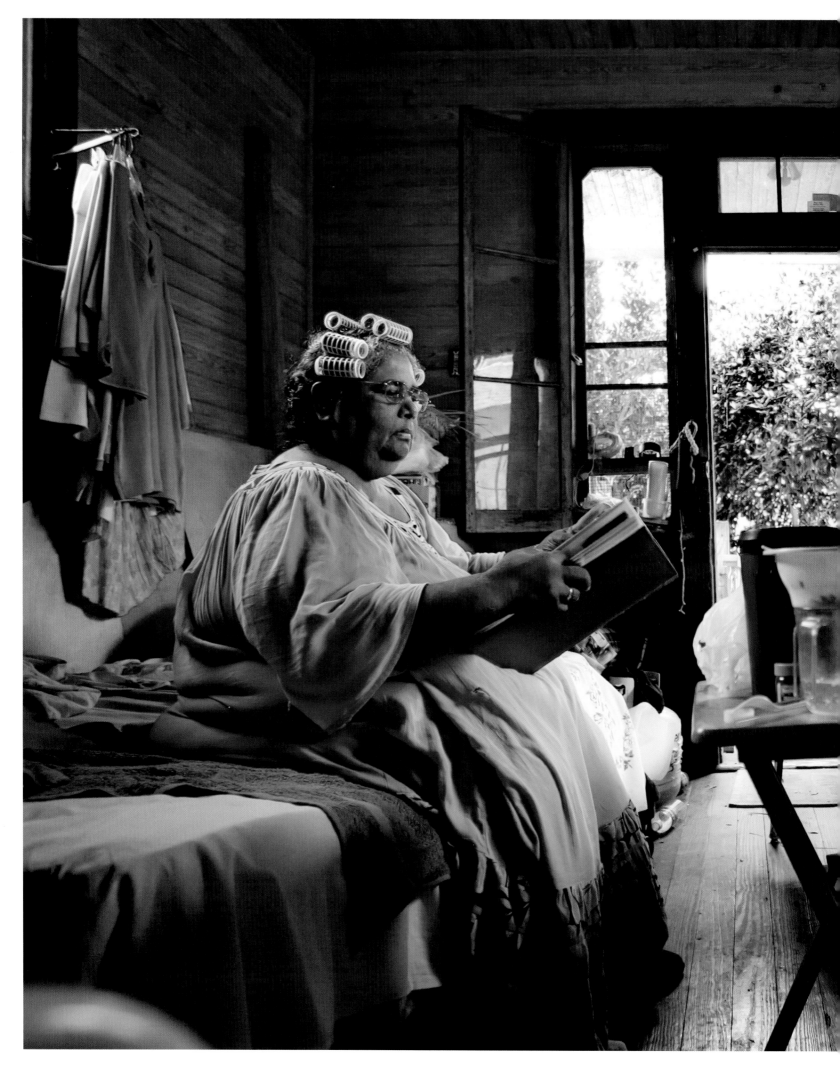

Retired seamstress Rita Gillett, 63, sits in her damaged home in the Lower Ninth Ward where she lives with her husband Hazzert, August 24, 2007, New Orleans. The couple still lived without electricity or gas because they weren't able to secure government assistance to pay for the repairs.

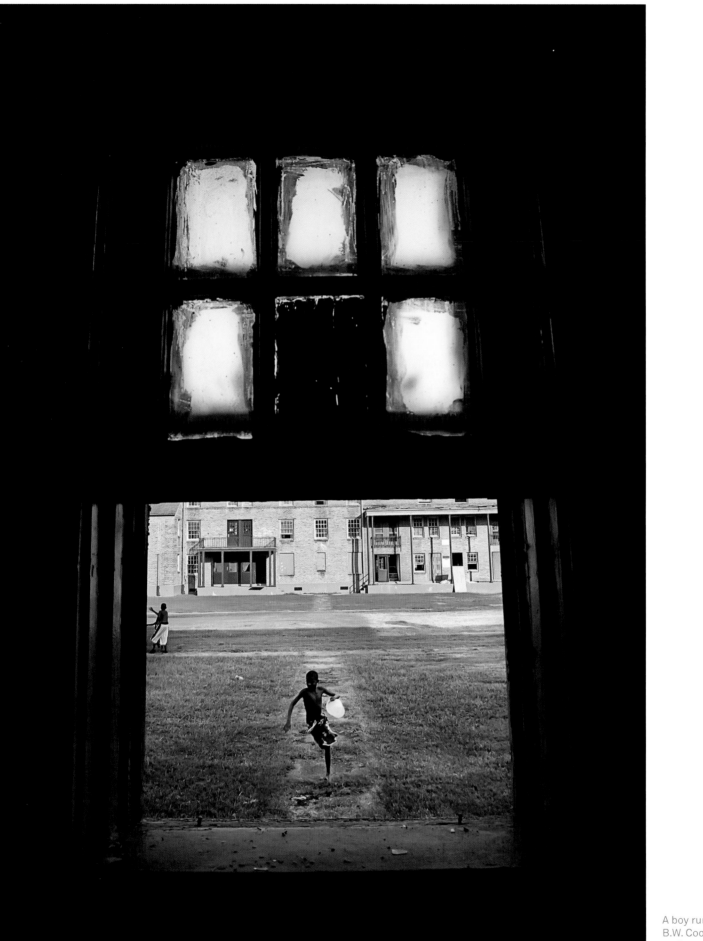

A boy runs in the B.W. Cooper housing project, August 25, 2007, New Orleans.

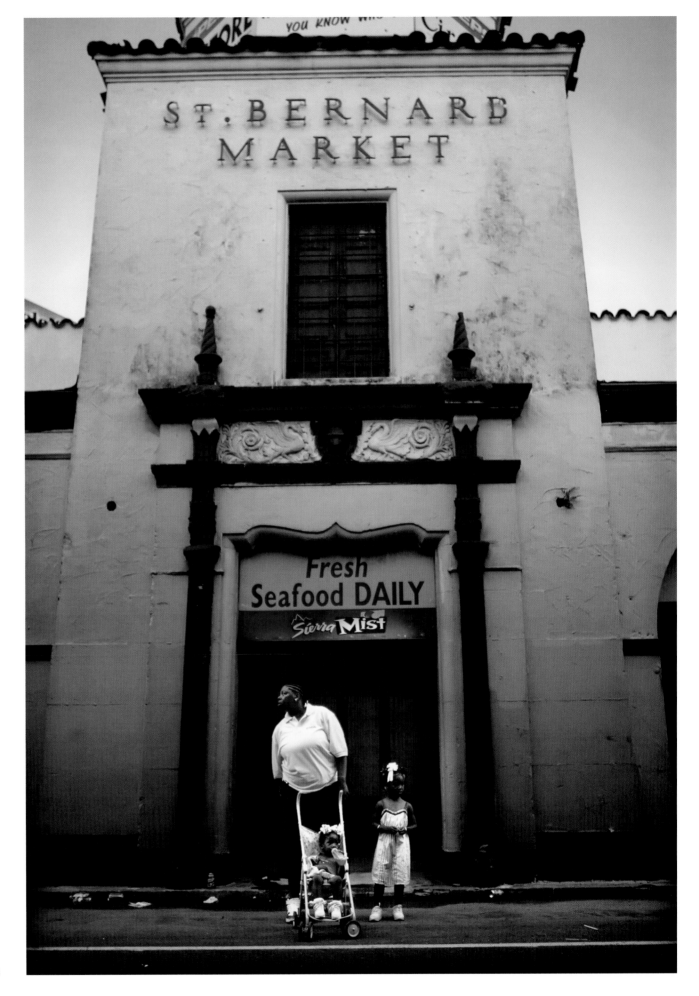

Spectators watch the annual Super Sunday Second Line Parade, May 25, 2008, in New Orleans

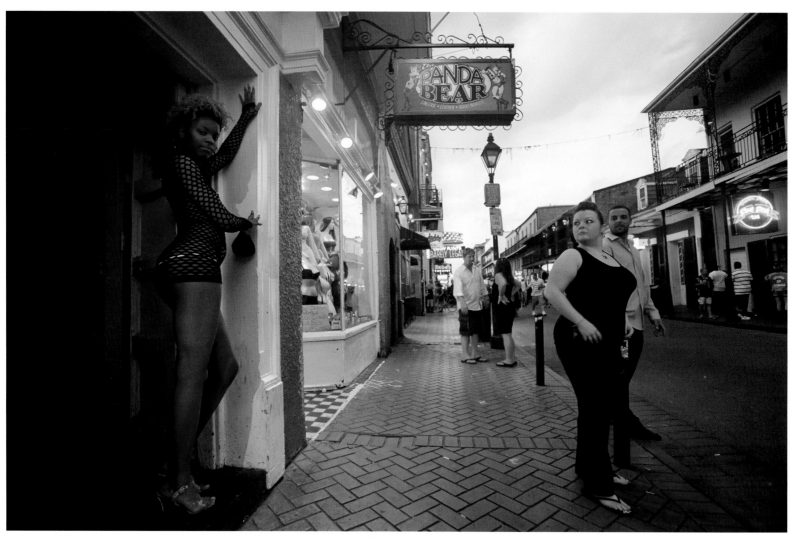

Leanna King (l) stands in the French Quarter, May 9, 2009, New Orleans.

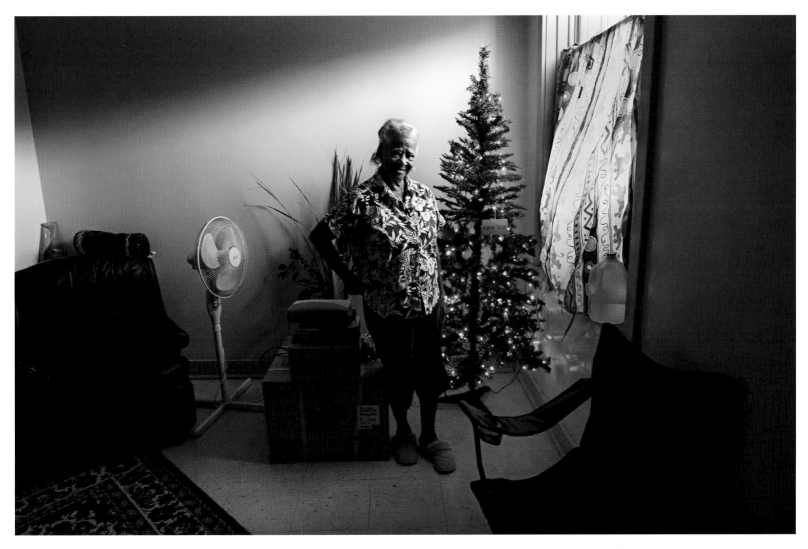

B.W. Cooper housing project resident Catherine Mundell stands by her Christmas tree in her living room, December 16, 2007, New Orleans.

"Watch New Orleanians walking down the street, they're looser, they're sexier in their movements, because of the beat in their heads, the beat they acknowledge without even thinking about it, just moving with it."

—CHARMAINE NEVILLE
"Come as You Are"

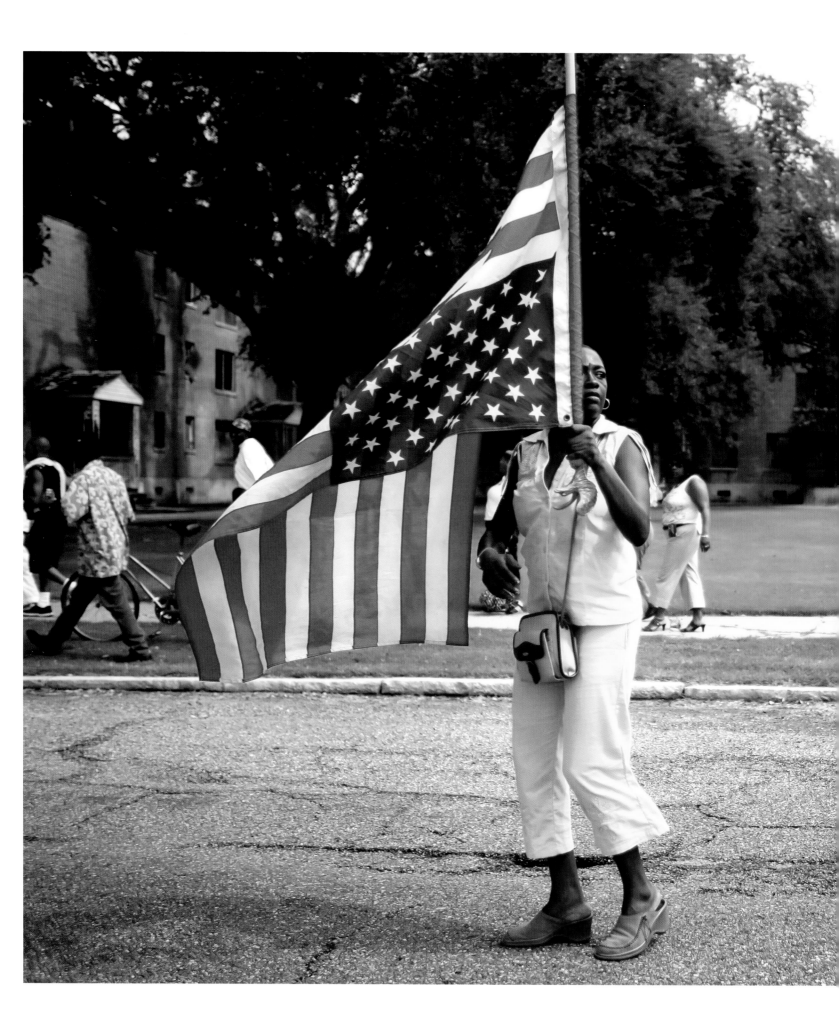

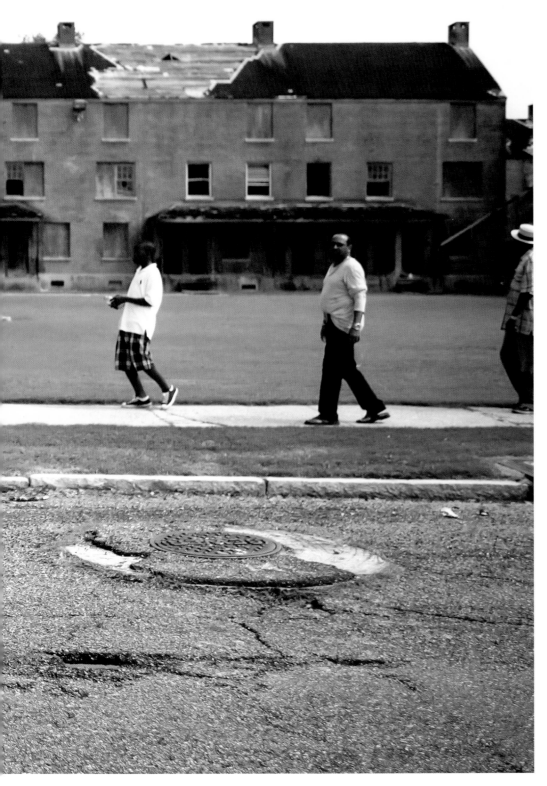

"The exuberance of sun, the fierceness of sudden rainstorms even when one is sheltered under a deep balcony, the dangers posed by a sullen lake and unpredictable river all give our days and our relationships an ardor that is not found in many places."

—PATRICK DUNNE
"Carlotta's Vases"

Betty Lee Ward carries an American flag past a damaged and shuttered housing project during the Valley of the Silent Men Social Aid and Pleasure Club Second Line Parade, August 26, 2007, New Orleans.

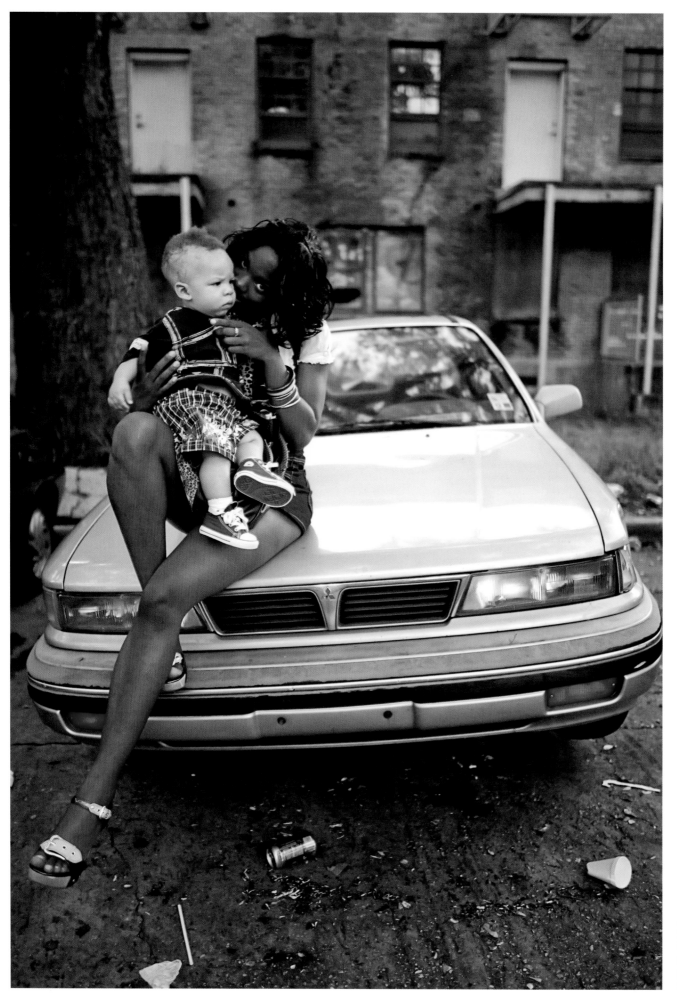

Ashley Williams holds
her cousin Tyren
Williams in the B.W.
Cooper housing
project, May 24, 2008,
New Orleans.

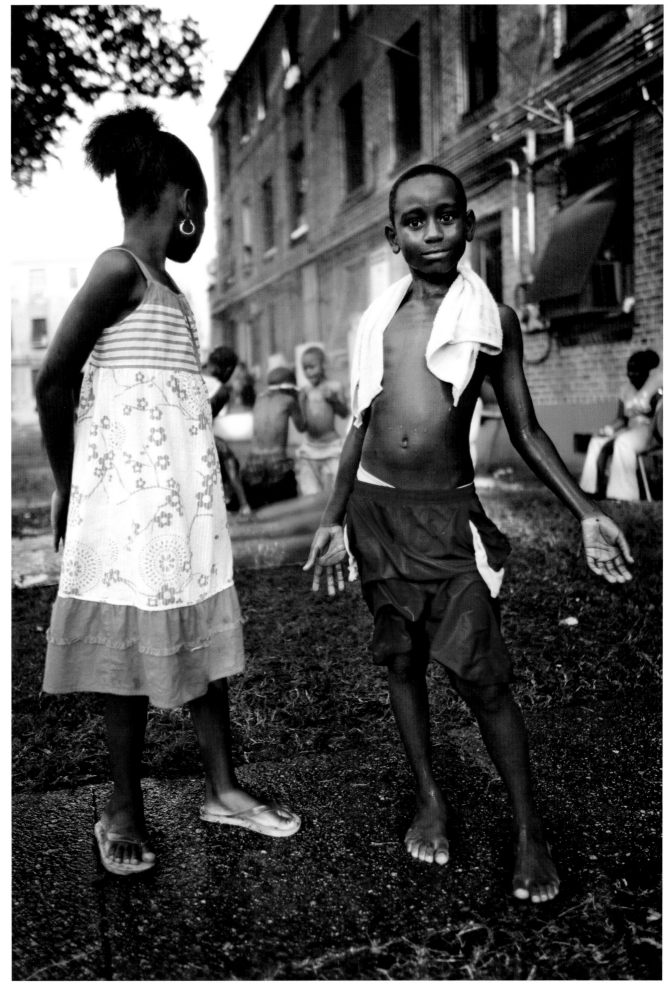

Caddrick and Chaddsity Smith look on by a small swimming pool in the B.W. Cooper housing project, June 10, 2007, New Orleans. The project was lacking in recreational areas.

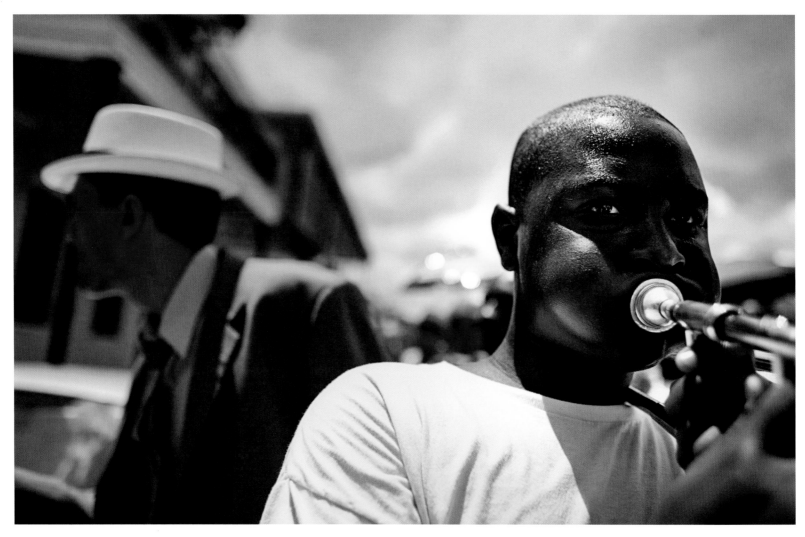

A parader plays his horn in the Satchmo Summerfest Second Line Parade,
August 6, 2006, New Orleans.

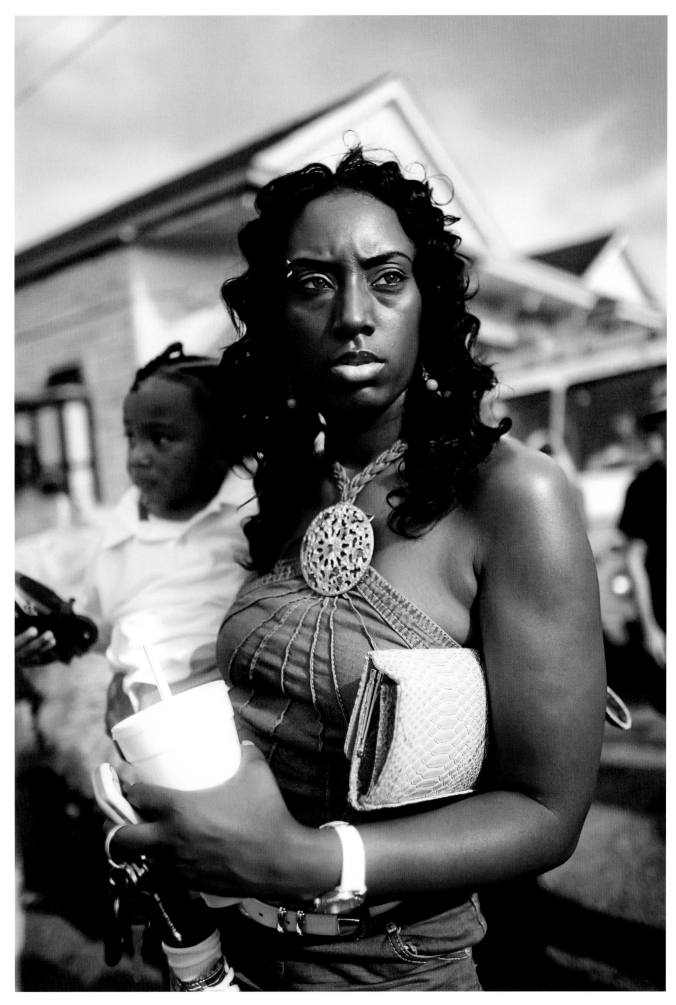

Coronda Thompson holds her son Toronn Thompson at the Original Big 7 Social Aid and Pleasure Club Second Line Parade in the Seventh Ward, May 10, 2009, New Orleans.

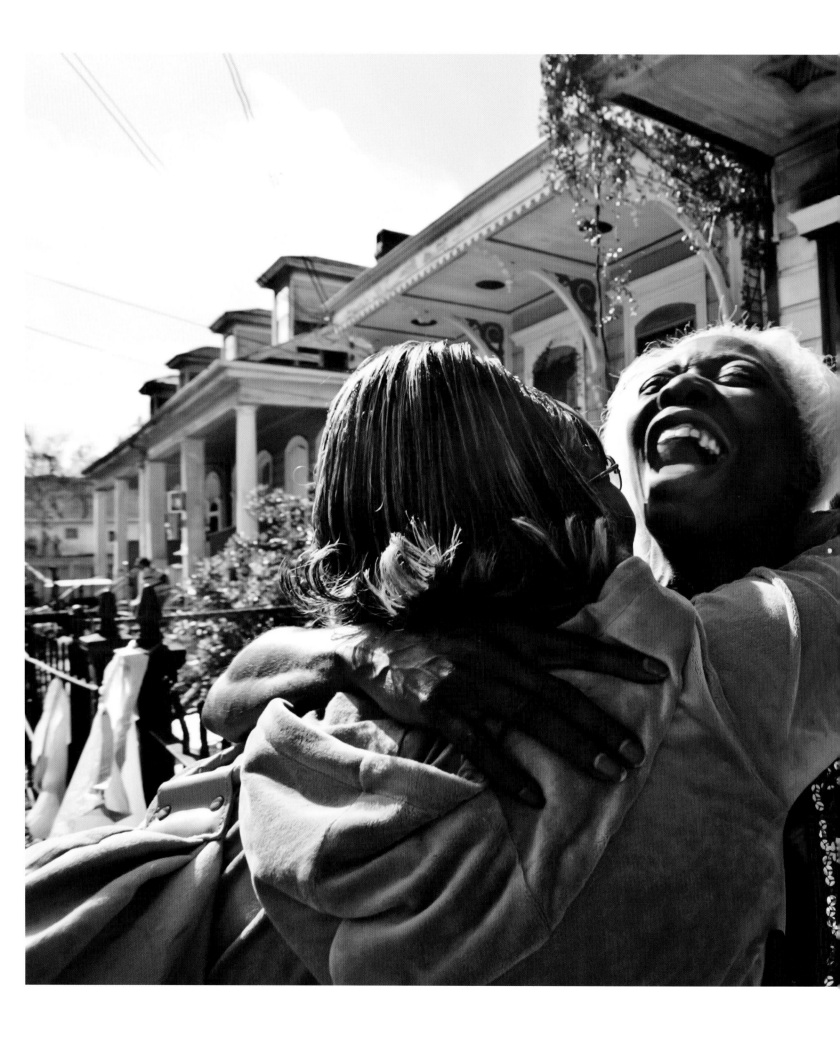

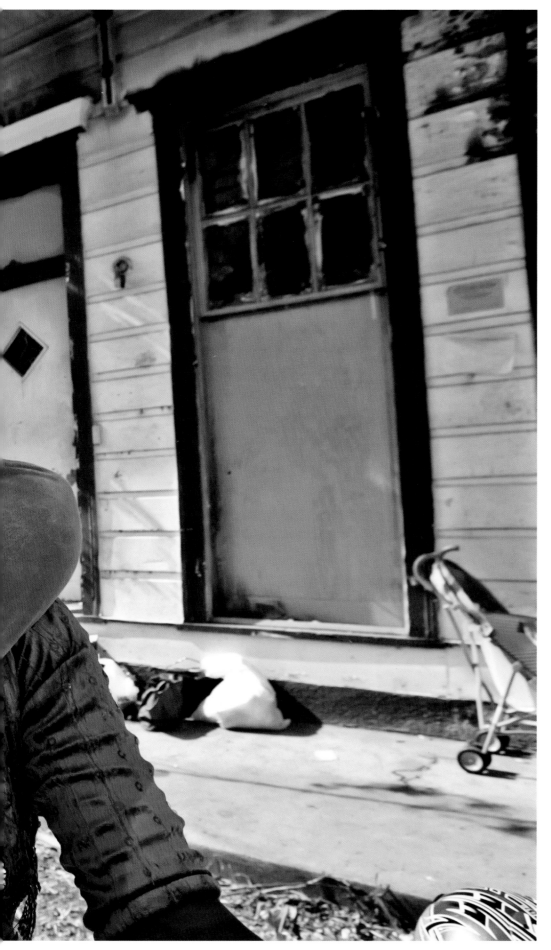

"The peculiar virtue of New Orleans, like St. Theresa, may be that of the Little Way, a talent for everyday life rather than the heroic deed."

—WALKER PERCY
"New Orleans Mon Amour"

Angela Perkins laughs with joy while hugging her niece at the Zulu Parade during Fat Tuesday Mardi Gras festivities, February 28, 2006, New Orleans. Perkins was evacuated to the Convention Center during Hurricane Katrina.

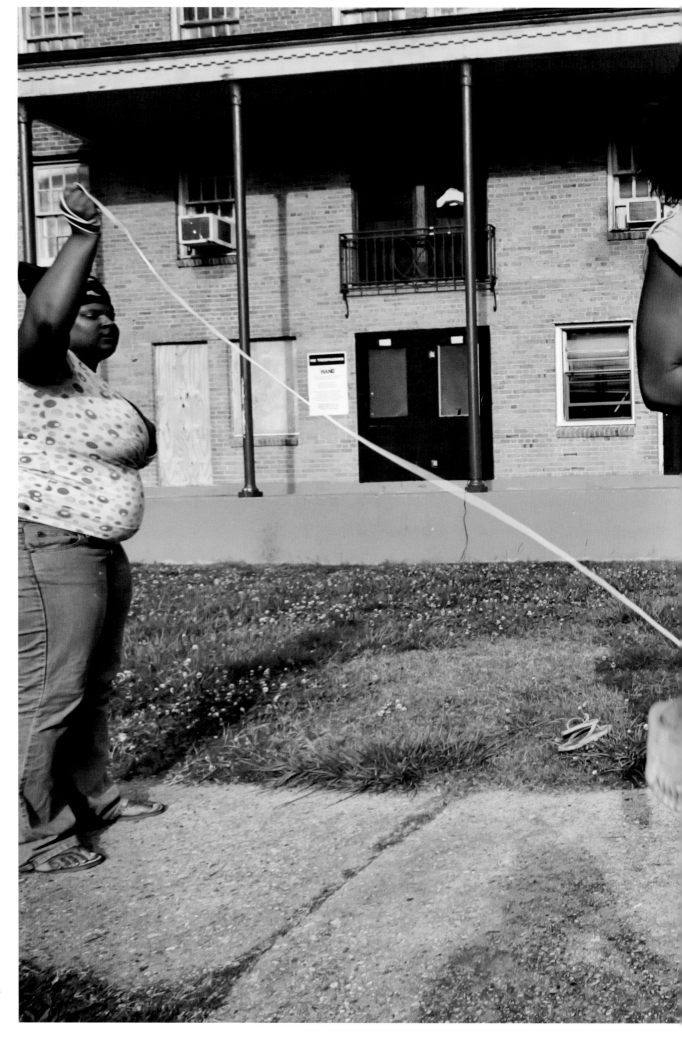

B.W. Cooper housing project resident Leianne LaRoche holds niece Destiny Herbert, two, as they jump rope using a phone cable in front of their apartment, June 6, 2007, New Orleans.

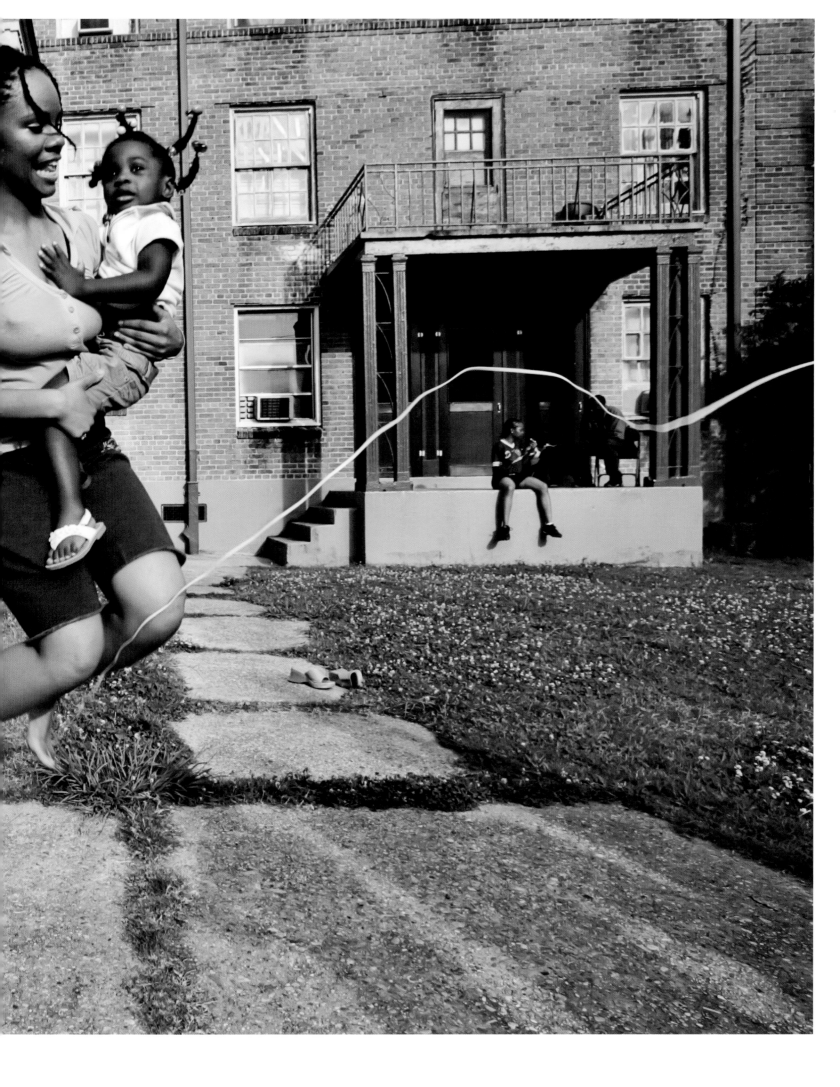

LEARN MORE

The Great Deluge: Hurricane Katrina, New Orleans, and the Mississippi Gulf Coast
Douglas Brinkley
New York, New York:
William Morrow, 2006

Breach of Faith: Hurricane Katrina and the Near Death of a Great American City
Jed Horne
New York, New York:
Random House, 2006

The Storm: What Went Wrong and Why During Hurricane Katrina—the Inside Story from One Louisiana Scientist
Ivor van Heerden, Mike Bryan
New York, New York:
Penguin, 2007

City Adrift: New Orleans Before and After Katrina
Jenni Bergal, Sara Shipley Hiles, Frank Koughan, John McQuaid, Jim Morris
Baton Rouge, Louisiana:
Louisiana State
University Press, 2007

1 Dead in Attic
Chris Rose
New York, New York:
Simon & Schuster, 2007

There is No Such Thing as a Natural Disaster: Race, Class, and Hurricane Katrina
Chester Hartman, Gregory D. Squires (editors)
New York, New York:
Routledge, 2006

The Sociology of Katrina: Perspectives on a Modern Catastrophe
David Brunsma, David Overfelt, Steve Picou
Lanham, Maryland:
Rowman & Littlefield
Publishers, Inc., 2007

Come Hell or High Water: Hurricane Katrina and the Color of Disaster
Michael Eric Dyson
New York, New York:
Basic Civitas Books, 2006

**Nine Lives: Mystery, Magic,
Death, and Life in New Orleans**
Dan Baum
New York, New York:
Spiegel & Grau, 2010

A.D.: New Orleans after the Deluge
Josh Neufeld
Graphic novel
New York, New York:
Pantheon, 2009

Tree House in a Storm
Rachelle Burk
Children's book
Gilsum, New Hampshire:
Stemmer House Publishers, 2009

**My New Orleans:
Ballads to the Big Easy by Her
Sons, Daughters, and Lovers**
Rosemary James (editor)
New York, New York:
Touchstone, 2006

**When the Levees Broke:
A Requiem in Four Acts**
Spike Lee (director)
Documentary, 2006

Trouble the Water
Carl Deal, Tia Lessin (directors)
Documentary, 2008

**Faubourg Tremé: The Untold
Story of Black New Orleans**
Dawn Logsdon, Lolis Eric Elie,
(directors)
Documentary, 2008

THE MISSION

To achieve excellent public schools for every child in New Orleans

New Schools for New Orleans is at the center of the fight to save a great city. A nonprofit, nongovernmental organization founded in the months after Katrina, NSNO has teamed with partners in and out of government to reinvent public education. It has scoured the city and the nation to recruit passionate, excellent educators. Teachers and principals alike, they have risen to the challenge of turning around what was, by many measures, the nation's most dysfunctional school system. NSNO has reinvigorated education by developing charter schools that foster independence, accountability and achievement by students and teachers. It supports school reform with direct grants and an array of services to enhance human capital—the men, women and children and the parents who are schooling's great resource. It also vigorously advocates for the public and philanthropic support required to sustain a remarkable success story.

New Orleans no longer has a school system. It has a dynamic system of schools. Some operate under a traditional central administration that answers to an elected school board; others—the ones that had failed for years under a centralized administration—were taken over by the state and turned into independent charter schools.

The preponderance of New Orleans public school students—61 percent—have opted for enrollment in chartered schools, the nation's largest commitment to this approach. Principals have gained the autonomy to manage their faculties as a meritocracy, rewarding those who demonstrate

certifiable improvement. Teachers have secured the leeway to bring their own creativity to bear in curricular design—and are held accountable if performance lags.

The early returns have been striking. As Katrina bore down on New Orleans most students were in schools that fell below the minimum standards for reading, math and English proficiency. By the 2008–9 school year, two-thirds of the city's public schools had been turned around, and the pace of improvement was accelerating.

New Orleans is a troubled big city with more than its share of poverty, crime, adult illiteracy and associated social ills. The catastrophe called Katrina left deep psychic scars on a generation of young people and cost many of them a full year of school before they were able to return. In that context, the performance gains in New Orleans schools are nothing less than spectacular. An excellent education is more than a matter of lessons learned. It is a matter of social justice. It is also, as New Orleans has learned, a matter of civic survival.

In five short years, public schooling in New Orleans has evolved from a national disgrace to a model lauded and closely studied by education leaders in Washington and across the country. New Schools for New Orleans is fighting to give New Orleans kids a future. In the past three years alone it has recruited 213 teachers and 19 school leaders now serving 96 percent of the city's open-enrollment charter schools. It has helped launch 10 new schools, serving 5,500 students, and funneled donations large and small—more than $20 million all told—to support and sustain them.

The mission is complex, but can be simply stated: to achieve excellent public schools for every child in New Orleans. To further this work, NSNO depends on the support of national philanthropies and individual donors. To learn more or make a contribution, visit NewSchoolsforNewOrleans.org or contact the organization's founder, Sarah Usdin, 200 Broadway, Suite 108, New Orleans, LA 70118; phone: (504) 274-3619; fax: (504) 274-3699.

NEW SCHOOLS FOR NEW ORLEANS

100% of the royalties from this book benefit New Schools for New Orleans, a nonprofit organization at the heart of a remarkably successful effort to overhaul public education in a recovering city.

ACKNOWLEDGMENTS

I am forever grateful for the incredible support from Getty Images CEO Jonathan Klein.

This project would never have come to fruition without the sterling vision of my Director of Photography, Pancho Bernasconi, along with our splendid editors, Sandy Ciric and Pierce Wright.

And the book itself would not have been possible without the cast-iron determination of Lauren Steel and Eric Rachlis.

I am thankful for the incredible support from my colleagues at Getty Images, especially:
Aidan Sullivan, Nick Evans-Lombe, Adrian Murrell, Brent Stirton, Chris Graythen, Christina Cahill, Peggy Willett, Molly McWhinnie, Sarah Hughes, Win McNamee, Mark Wilson, Spencer Platt, Chris Hondros, Joe Raedle, Justin Sullivan, Rick Gershon, Chris McGrath, John Moore, Paula Bronstein, Chip Somodevilla, Scott Olson, Alex Wong, Kevork Djansezian, David McNew, Andreas Gebhard, and all the terrific folks on the Picture Desk, Abby Loewenstein, Travis Lindquist, Meggie Foust, Allen Stephens, Katie Calhoun, Jason Camhi, and Harold Cook.

Thanks to Dr. Nayana Abeysinghe for meticulous research and writing assistance.

I would like to give special thanks to those photographers and reporters who provided much appreciated assistance in New Orleans:
Lee Celano, Chris Granger, James Nielsen, Shannon Stapleton, Jason Reed, Mark Egan, Mike Christie, David Grunfeld, Alex Brandon, Tyler Hicks, Carolyn Cole, Alan Chin, Terri Sercovich, Robyn Beck, Mira Oberman, Yunghi Kim, Michael Nagle, Radhika Chalasani, Sean Gardner, Andy Levin, Bill Haber, Jake Price, and Stanley Greene.

Heartfelt thanks to my friends in Louisiana and Mississippi:
Antonia Keller, Kathleen Graythen, Hazzert and Rita Gillett, Courtney Barthelemy and all the Barthelemys, Mark Shea, Siona LaFrance, Jacquelyn Boyd, Jermaine and Sharon Brisco, Dave and Danielle DiMaggio, Robert Green, Antoinette Harrell, Ride Hamilton, Darrell Williams, Andrew Thomas, Aubrey Watson, Annie Richburg, Charles Jackson, Dennis McSeveney, Anne DiPaola, Shanika Reaux, Ira Jackson,

Adonis Expose, Julia McNabb, Laura Paul, Kathleen Padian, Errol Schultz, Brenda Marie Osbey, Willi Lee, Cuthbert O'Connell, Lonnie Kent, Condita Duplessis, Edward Buckner, Jamie Riley, Shelley Phillips, Alan Sessum, Catherine Mundell, Matt and Lynn at Crescent City Guest House, the Original Big 7 Social Aid and Pleasure Club, the Valley of the Silent Men Social Aid and Pleasure Club, the Original New Orleans Ladies, Kids and Men Buckjumpers, and all of the people who welcomed me at B.W. Cooper housing and at Diamond travel trailer park.

I would like to thank the amazing team at National Geographic including: Gail Fisher, David Griffin, Maggie Zackowitz, Elizabeth Snodgrass, and Beth Foster.

Thanks also to my friends and colleagues who provided encouragement and assistance in completing this work:
Michael Sargent, Alyssa Adams, Jonathan Torgovnik, Tim Hetherington, Craig Allen, Robert Giroux, Jeremiah Bogert, Laura Malone, Phaedra Singelis, Meredith Birkett, Christopher Anderson, Laura Buchwald, David Butow, Richard Ellis, Q Sakamaki, Jamie Wellford, Tripti Lahiri, Javier Salinas, Jennifer Eggleston, Dan Eckstein, Tina Ahrens, Darren Ching, Nicholas McClelland, Travis Hartman, Donald Winslow, Bruce Young, Michael Shaw, Paul Heltzel, Coburn Dukehart, Ruth Fremson, Michael Robinson-Chavez, Dudley Brooks, Tim Reusing, Julie Hyman, Dan Royer, Keith Liddle, Mike Segar, Yolanda Torrubia, Shveta Trivedi, Elizabeth Sacre, Aamna Dehlavi, Athena Jones, Russell Sinclair, Nena Sinclair, and Jim Lowney.

Thanks to those whose sage guidance has been central:
Bill Perry, Bob Pearson, Ray Saunders, Stephen Jaffe, Patrick and Mish Whalen, Joe Elbert, Claudia Rosenbaum, Michael DuCille, Stephen Crowley, Lon Slepicka, Guenther Cartwright, Loret Steinberg, Dan Larkin, Tim Sloan, Dan Gross, Bill Ryan, Ron Agnir, and Frank Stallings.

Thanks to my wonderful publisher Nan Richardson, who believed in this work, along with Ashley Singley, Jennifer Kakaletris, and Aileen Shin at Umbrage Editions.

Special thanks to digital guru David Hazan at Picturehouse NYC and to Ken Horowitz.

Thanks to Anderson Cooper for the gracious introduction and courageous reporting, and to his stellar producer Charlie Moore.

I am eternally grateful to my parents, Mario and Elaine, and my brother Jason, for their love and support.

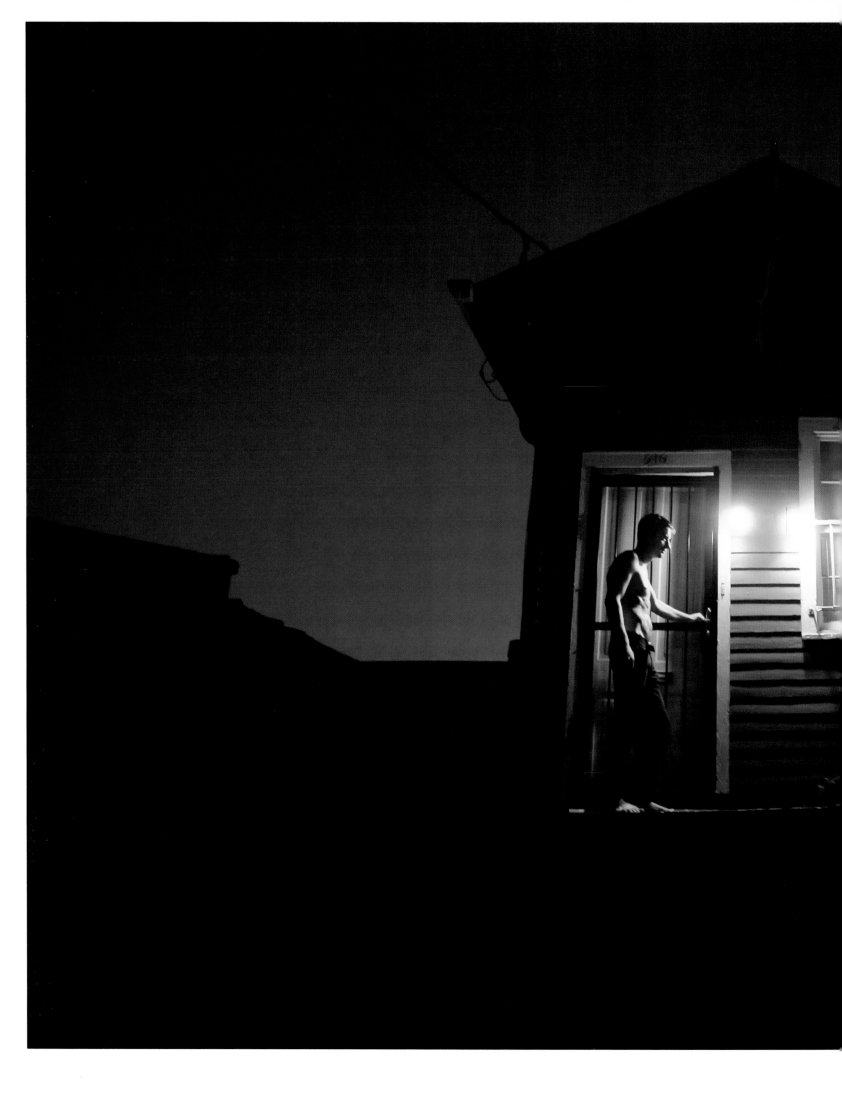

Brian Suthers stands
on the front porch of
his Faubourg Marigny
home, August 23, 2007,
New Orleans.

An Umbrage Editions book
Publisher: Nan Richardson
Associate Editor: Ashley Singley
Designer: Jennifer Kakaletris
Assistant Designer: Aileen Shin
Copy Editor: Amanda Bullock and Chesley Hicks
Photo Editor / Getty Images: Lauren Steel
Assistant Editors: Eleanor Levinson and Alexa Smith

Umbrage Editions, Inc.
111 Front Street, Suite 208
Brooklyn, NY 11201
www.umbragebooks.com

Distributed in the US and Canada by Consortium
www.cbsd.com

Printed in China